Flaxman's Illustrations
for Dante's
Divine Comedy

John Flaxman

DOVER PUBLICATIONS, INC.
Mineola, New York

Bibliographical Note

This Dover edition, first published in 2007, contains 110 plates from *Compositions from The Hell, Purgatory, and Paradise of Dante Alighieri* by John Flaxman, with engravings by Thomas Piroli, originally published by Longman, Hurst, Rees, and Orme, London, in 1807. Facing each plate is the accompanying verse from Henry Wadsworth Longfellow's translation of *The Divine Comedy of Dante Alighieri,* as published by Houghton, Mifflin and Company, Boston, in 1895. Quotation marks that either preceded or followed the selected verse have been added here for consistency. In addition, a brief extract from Longfellow's text has been run as a caption below each plate. Please note that one plate, "Faith, Hope, and Charity," printed on p. 155, has no accompanying text.

Library of Congress Cataloging-in-Publication Data

Flaxman, John, 1755–1826.
 Flaxman's illustrations for Dante's Divine comedy / John Flaxman. — Dover ed.
 p. cm.
 Contains 110 plates from "Compositions from The Hell, Purgatory, and Paradise of Dante Alighieri" by John Flaxman, with engraving by Thomas Piroli, originally published by Longman, Hurst, Rees, and Orme, London, in 1807.
 ISBN 0-486-45558-0 (pbk.)
 1. Dante Alighieri, 1265–1321. Divina commedia—Illustrations. I. Dante Alighieri, 1265–1321. Divina commedia. II. Title. III. Title: Illustrations for Dante's Divine comedy.

PQ4329.F546 2007
851'.1—dc22

2006048831

Manufactured in the United States of America
Dover Publications, Inc., 31 East 2nd Street, Mineola, N.Y. 11501

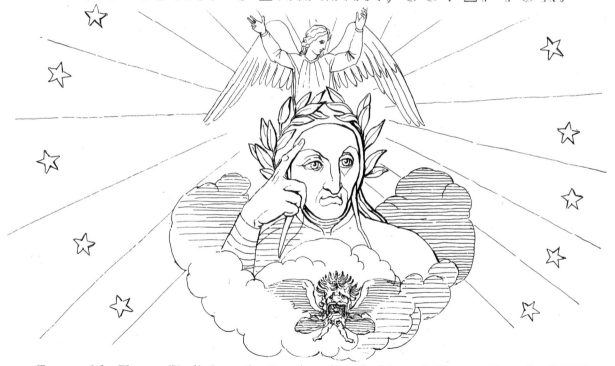

COMPOSITIONS
FROM
THE HELL, PVRGATORY, AND PARADISE,
OF
DANTE ALIGHIERI,
BY IOHN FLAXMAN, SCVLPTOR.

Engraved by Thomas Piroli, from the Drawings in Possession of Thomas Hope Esqr. 1793.

[Original title page]

Entering the Dark Wood
Canto I, lines 124–136

ecause that Emperor, who reigns above,
 In that I was rebellious to his law,
 Wills that through me none come into his city.
He governs everywhere, and there he reigns;
 There is his city and his lofty throne;
 O happy he whom thereto he elects!"
And I to him: "Poet, I thee entreat,
 By that same God whom thou didst never know,
 So that I may escape this woe and worse,
Thou wouldst conduct me there where thou hast said,
 That I may see the portal of Saint Peter,
 And those thou makest so disconsolate."
Then he moved on, and I behind him followed.

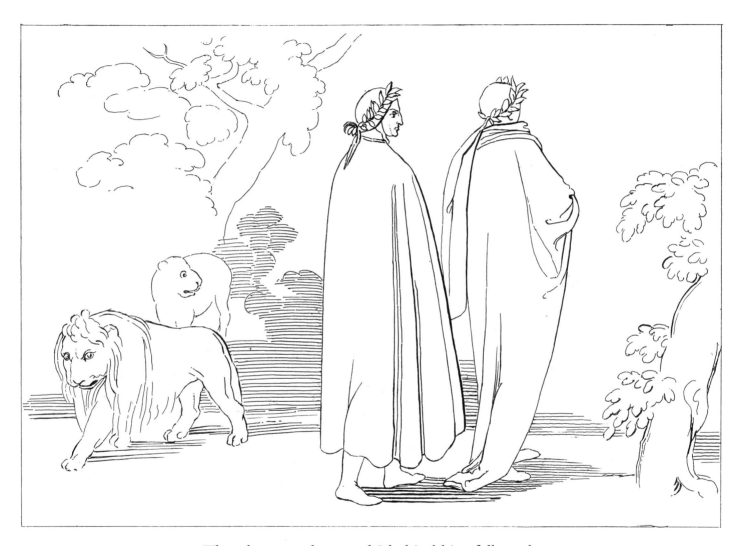

Then he moved on, and I behind him followed.

Virgil and Beatrice Meeting
Canto II, lines 52–60

Among those was I who are in suspense,
 And a fair, saintly Lady called to me
 In such wise, I besought her to command me.
Her eyes were shining brighter than the Star;
 And she began to say, gentle and low,
 With voice angelical, in her own language:
'O spirit courteous of Mantua,
 Of whom the fame still in the world endures,
 And shall endure, long-lasting as the world'

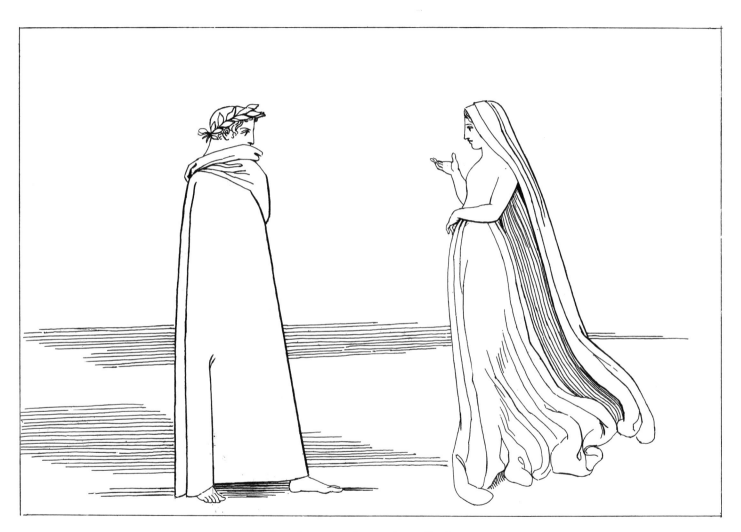

And a fair, saintly Lady called to me

Charon's Boat
Canto III, lines 109–120

Charon the demon, with the eyes of glede,
 Beckoning to them, collects them all together,
 Beats with his oar whoever lags behind.
As in the autumn-time the leaves fall off,
 First one and then another, till the branch
 Unto the earth surrenders all its spoils;
In similar wise the evil seed of Adam
 Throw themselves from that margin one by one,
 At signals, as a bird unto its lure.
So they depart across the dusky wave,
 And ere upon the other side they land,
 Again on this side a new troop assembles.

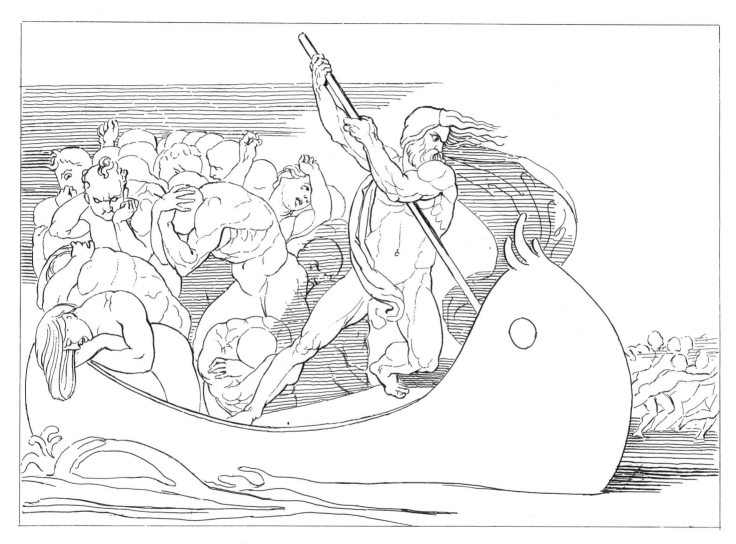

So they depart across the dusky wave

Christ's Descent to Limbo
Canto IV, lines 46–54

"Tell me, my Master, tell me, thou my Lord,"
 Began I, with desire of being certain
 Of that Faith which o'ercometh every error,
"Came any one by his own merit hence,
 Or by another's, who was blessed thereafter?"
 And he, who understood my covert speech,
Replied: "I was a novice in this state,
 When I saw hither come a Mighty One,
 With sign of victory incoronate."

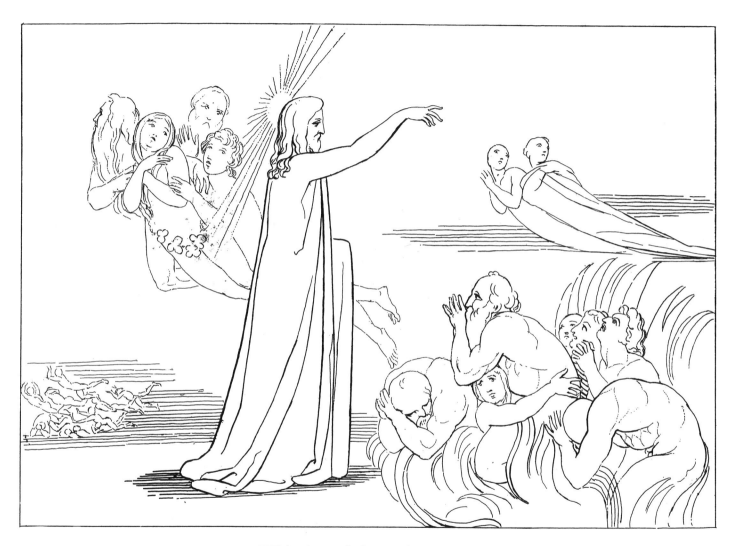

With sign of victory incoronate

The Lovers Surprised

Canto V, lines 127–136

One day we reading were for our delight
Of Launcelot, how Love did him enthral.
Alone we were and without any fear.
Full many a time our eyes together drew
That reading, and drove the colour from our faces;
But one point only was it that o'ercame us.
When as we read of the much-longed-for smile
Being by such a noble lover kissed,
This one, who ne'er from me shall be divided,
Kissed me upon the mouth all palpitating.

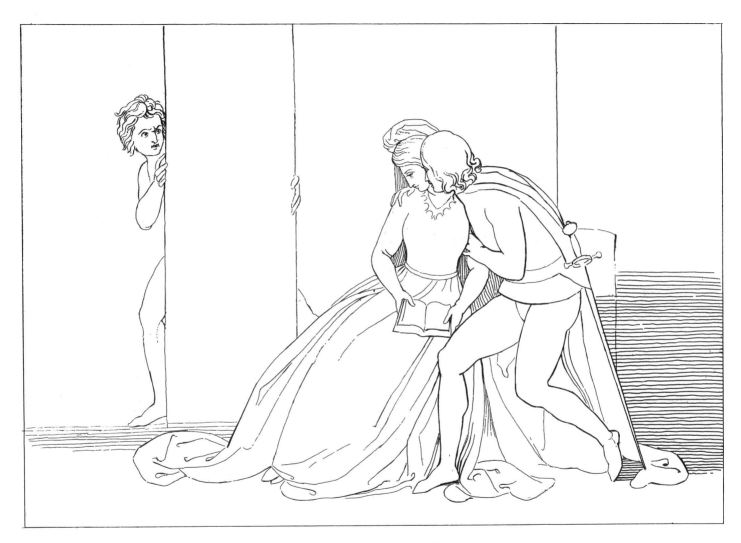

Kissed me upon the mouth all palpitating

The Lovers Punished

Canto V, lines 139–142

And all the while one spirit uttered this,
The other one did weep so, that, for pity,
I swooned away as I had been dying,
And fell, even as a dead body falls.

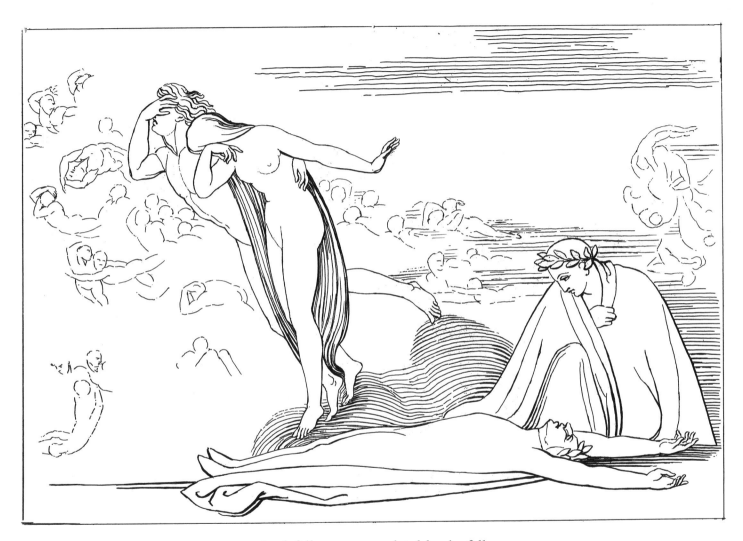

And fell, even as a dead body falls

Cerberus

Canto VI, lines 13–18

Cerberus, monster cruel and uncouth,
 With his three gullets like a dog is barking
 Over the people that are there submerged.
Red eyes he has, and unctuous beard and black,
 And belly large, and armed with claws his hands;
 He rends the spirits, flays, and quarters them.

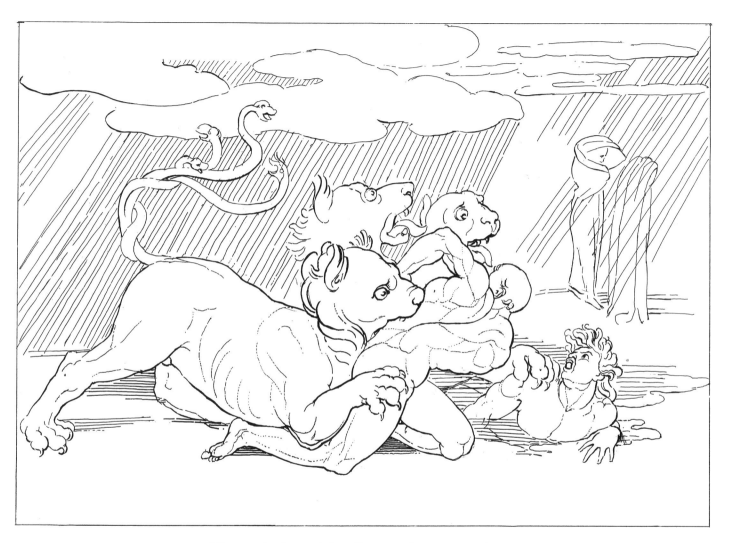

He rends the spirits, flays, and quarters them

The Region of Pluto
Canto VII, lines 1–6

Papë Satàn, Papë Satàn, Aleppë!"
Thus Plutus with his clucking voice began;
And that benignant Sage, who all things knew,
Said, to encourage me: "Let not thy fear
Harm thee; for any power that he may have
Shall not prevent thy going down this crag."

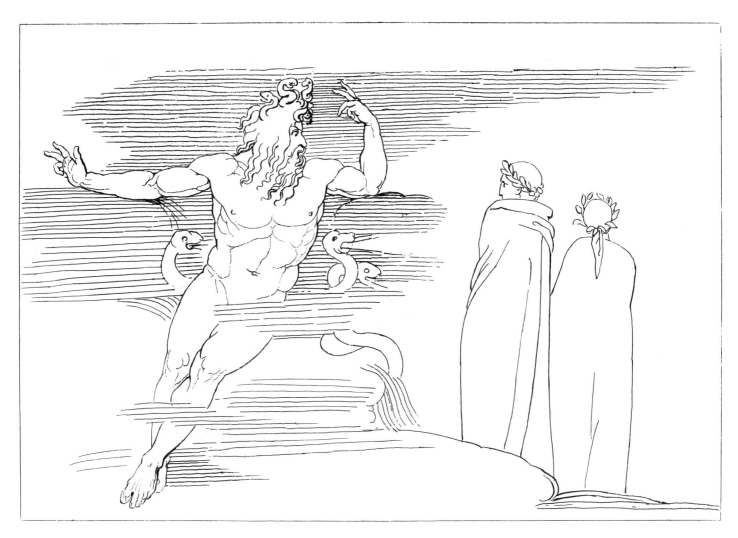

"Papë Satàn, Papë Satàn, Aleppë!"

The Pool of Envy

Canto VIII, lines 67–75

And the good Master said: "Even now, my Son,
 The city draweth near whose name is Dis,
 With the grave citizens, with the great throng."
And I: "Its mosques already, Master, clearly
 Within there in the valley I discern
 Vermilion, as if issuing from the fire
They were." And he to me: "The fire eternal
 That kindles them within makes them look red,
 As thou beholdest in this nether Hell."

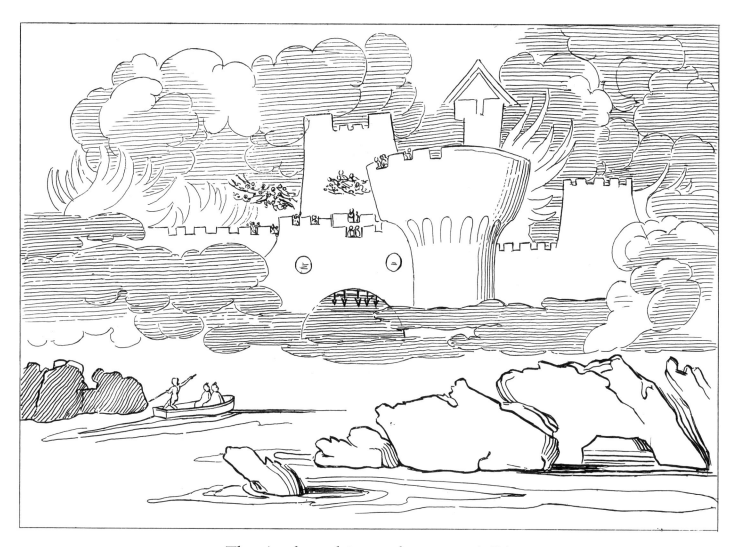

The city draweth near whose name is Dis

The Furies

Canto IX, lines 43–48

And he who well the handmaids of the Queen
 Of everlasting lamentation knew,
 Said unto me: "Behold the fierce Erinnys.
This is Megæra, on the left-hand side;
 She who is weeping on the right, Alecto;
 Tisiphone is between;" and then was silent.

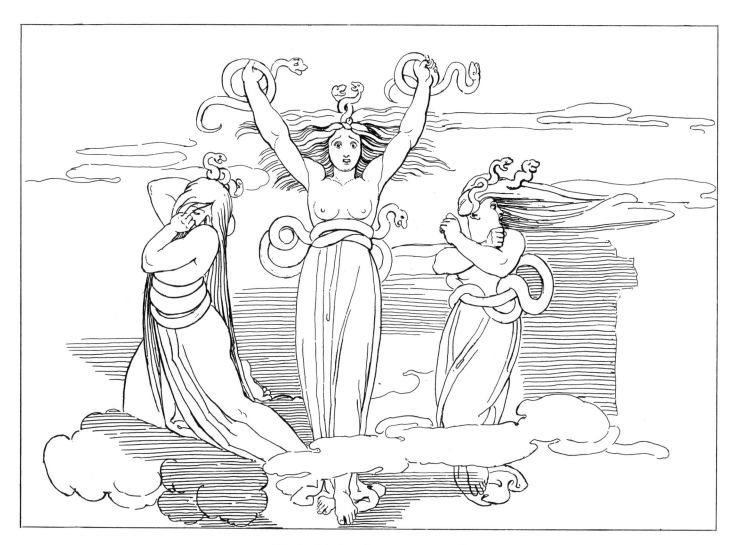

"Behold the fierce Erinnys."

The Fiery Sepulchres
Canto X, lines 28–36

Upon a sudden issued forth this sound
 From out one of the tombs; wherefore I pressed,
 Fearing, a little nearer to my Leader.
And unto me he said: "Turn thee; what dost thou?
 Behold there Farinata who has risen;
 From the waist upwards wholly shalt thou see him."
I had already fixed mine eyes on his,
 And he uprose erect with breast and front
 E'en as if Hell he had in great despite.

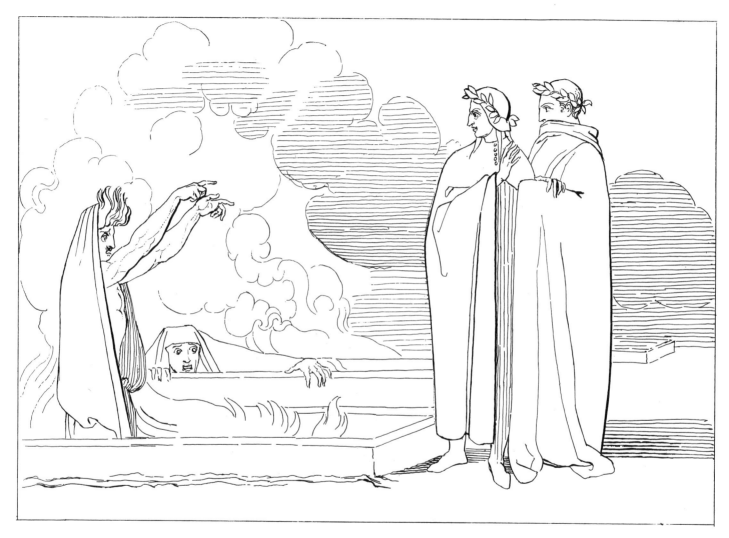

"Behold there Farinata who has risen"

Tomb of Anastasius
Canto XI, lines 1–9

Upon the margin of a lofty bank
 Which great rocks broken in a circle made,
 We came upon a still more cruel throng;
And there, by reason of the horrible
 Excess of stench the deep abyss throws out,
 We drew ourselves aside behind the cover
Of a great tomb, whereon I saw a writing,
 Which said: "Pope Anastasius I hold,
 Whom out of the right way Photinus drew."

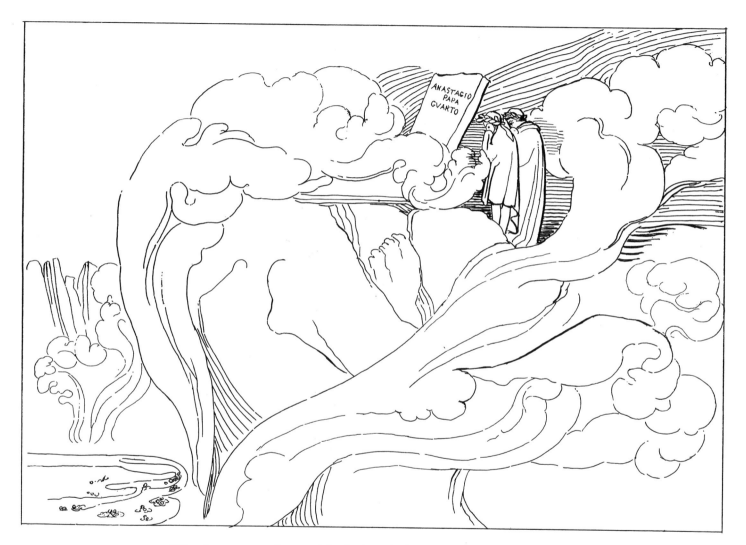

We drew ourselves aside behind the cover of a great tomb

Encounter with the Centaurs
Canto XII, lines 58–63

Beholding us descend, each one stood still,
 And from the squadron three detached themselves,
 With bows and arrows in advance selected;
And from afar one cried: "Unto what torment
 Come ye, who down the hillside are descending?
 Tell us from there; if not, I draw the bow."

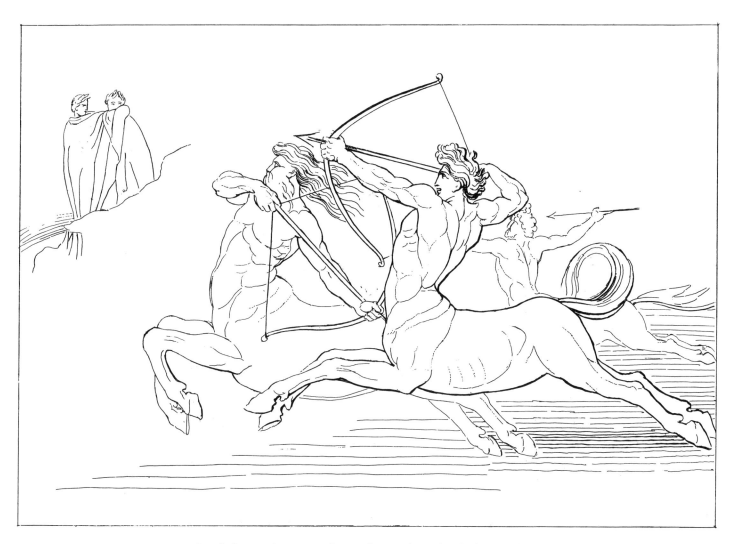

And from the squadron three detached themselves

Forest of Harpies
Canto XIII, lines 28–36

Therefore the Master said: "If thou break off
 Some little spray from any of these trees,
 The thoughts thou hast will wholly be made vain."
Then stretched I forth my hand a little forward,
 And plucked a branchlet off from a great thorn;
 And the trunk cried, "Why dost thou mangle me?"
After it had become embrowned with blood,
 It recommenced its cry: "Why dost thou rend me?
 Hast thou no spirit of pity whatsoever?"

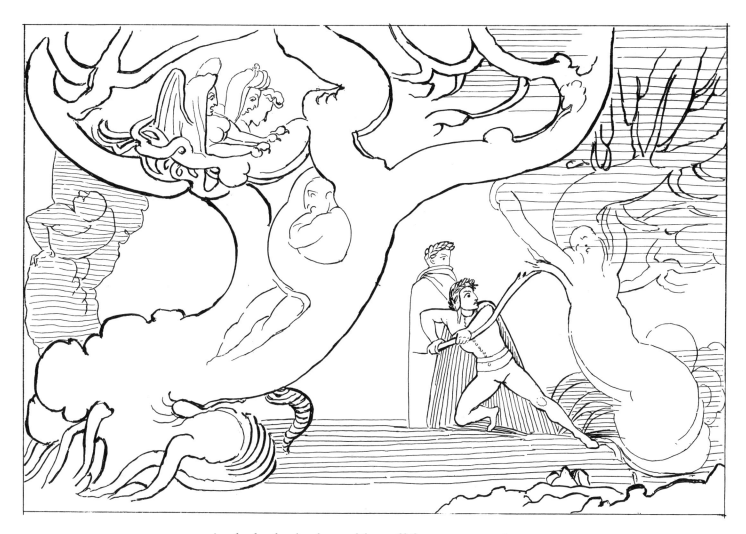

And plucked a branchlet off from a great thorn

The Statue of Four Metals
Canto XIV, lines 103–108

A grand old man stands in the mount erect,
 Who holds his shoulders turned tow'rds Damietta,
 And looks at Rome as if it were his mirror.
His head is fashioned of refined gold,
 And of pure silver are the arms and breast;
 Then he is brass as far down as the fork.

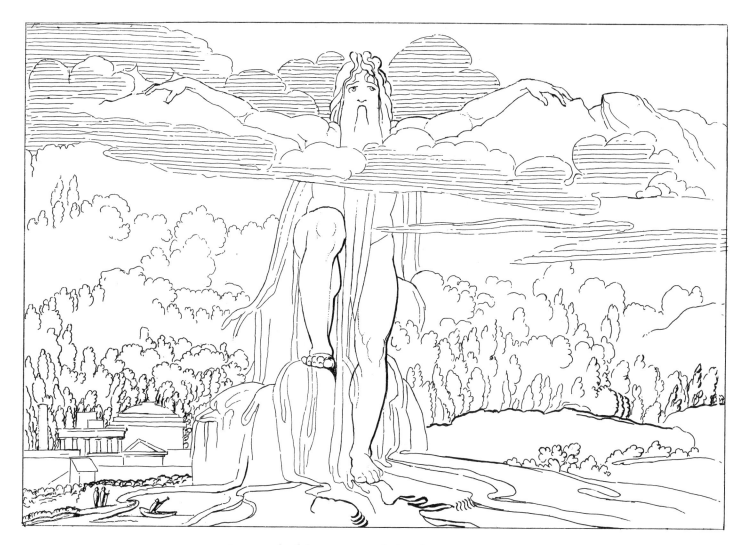

A grand old man stands in the mount erect

Dante Discoursing with his Preceptor
Canto XV, lines 43–48

I did not dare to go down from the road
 Level to walk with him; but my head bowed
 I held as one who goeth reverently.
And he began: "What fortune or what fate
 Before the last day leadeth thee down here?
 And who is this that showeth thee the way?"

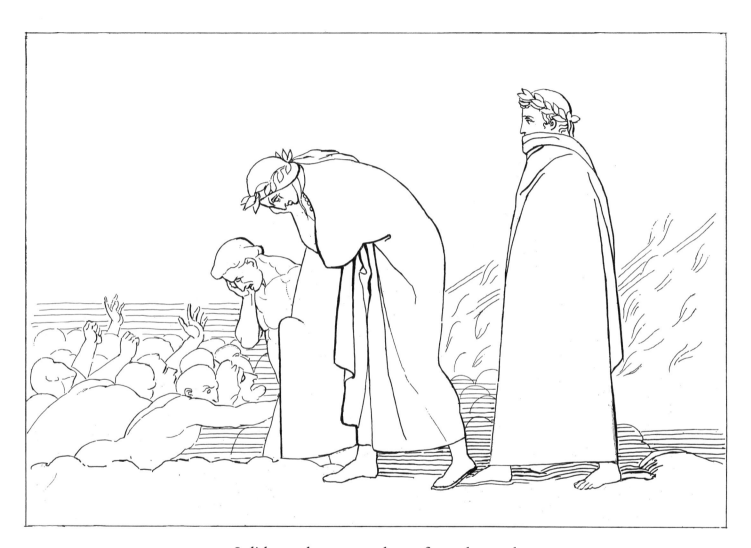

I did not dare to go down from the road

The Rain of Fire

Canto XVI, lines 22–27

As champions stripped and oiled are wont to do,
 Watching for their advantage and their hold,
 Before they come to blows and thrusts between them,
Thus, wheeling round, did every one his visage
 Direct to me, so that in opposite wise
 His neck and feet continual journey made.

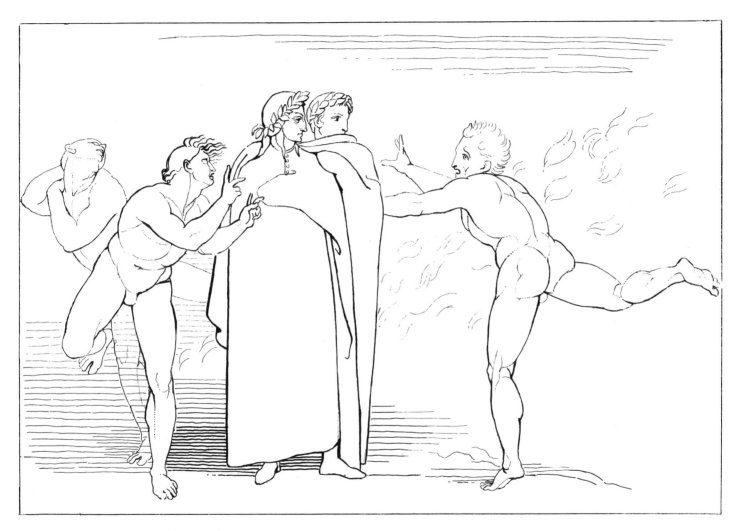

Thus, wheeling round, did every one his visage direct to me

Geryon

Canto XVII, lines 106–114

A greater fear I do not think there was
What time abandoned Phaeton the reins,
Whereby the heavens, as still appears, were scorched;
Nor when the wretched Icarus his flanks
Felt stripped of feathers by the melting wax,
His father crying, "An ill way thou takest!"
Than was my own, when I perceived myself
On all sides in the air, and saw extinguished
The sight of everything but of the monster.

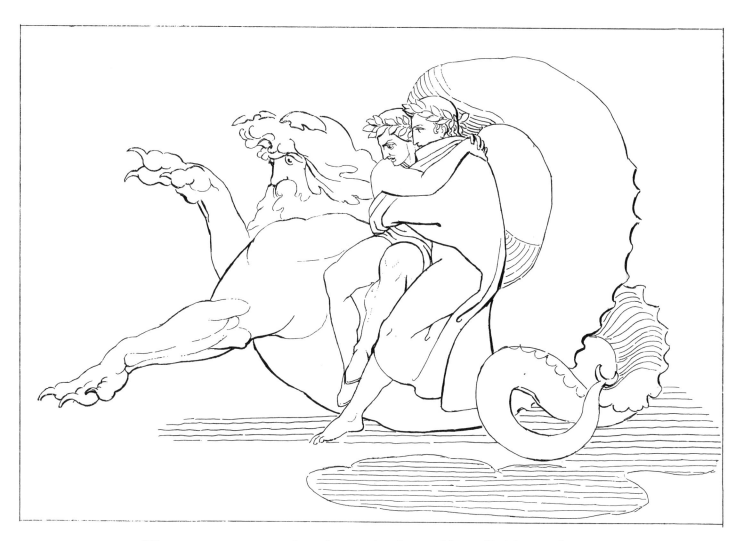

Than was my own, when I perceived myself on all sides in the air

Malebolge
Canto XVIII, lines 103–114

Thence we heard people, who are making moan
 In the next Bolgia, snorting with their muzzles,
 And with their palms beating upon themselves
The margins were incrusted with a mould
 By exhalation from below, that sticks there,
 And with the eyes and nostrils wages war.
The bottom is so deep, no place suffices
 To give us sight of it, without ascending
 The arch's back, where most the crag impends.
Thither we came, and thence down in the moat
 I saw a people smothered in a filth
 That out of human privies seemed to flow.

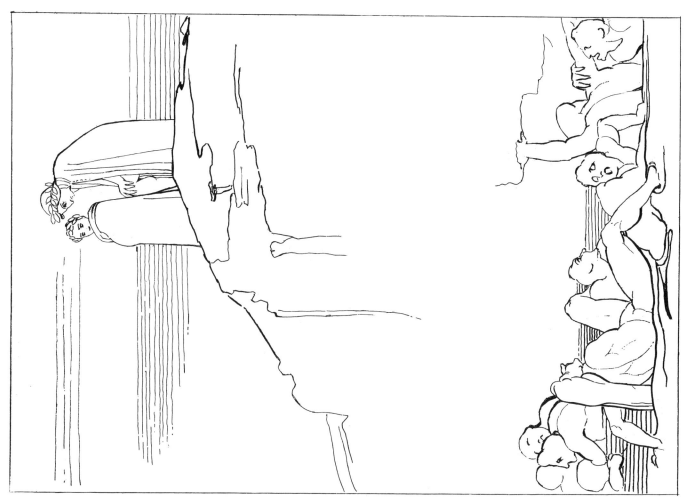

I saw a people smothered in a filth

The Gulf of Simony
Canto XIX, lines 40–48

Straightway upon the fourth dike we arrived;
 We turned, and on the left-hand side descended
 Down to the bottom full of holes and narrow.
And the good Master yet from off his haunch
 Deposed me not, till to the hole he brought me
 Of him who so lamented with his shanks.
"Whoe'er thou art, that standest upside down,
 O doleful soul, implanted like a stake,"
 To say began I, "if thou canst, speak out."

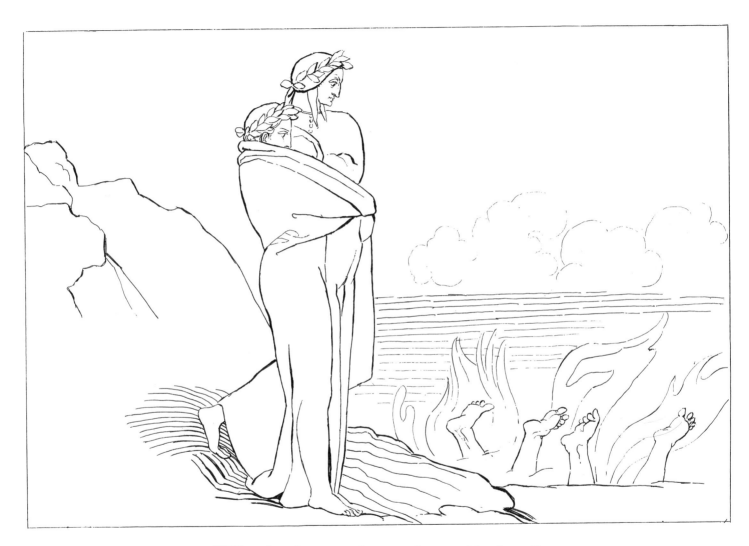

"Whoe'er thou art, that standest upside down"

Tiresias
Canto XX, lines 40–45

Behold Tiresias, who his semblance changed,
When from a male a female he became,
His members being all of them transformed;
And afterwards was forced to strike once more
The two entangled serpents with his rod,
Ere he could have again his manly plumes.

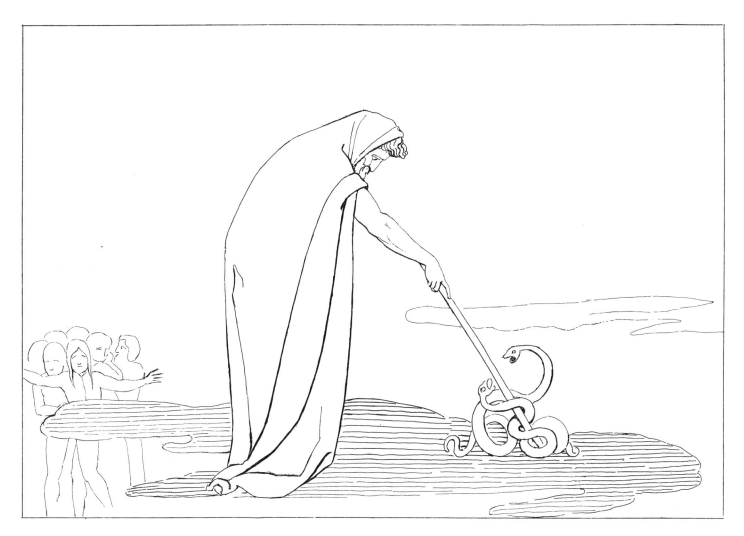

Behold Tiresias

Summit of Malebolge

Canto XXI, lines 25–37

Then I turned round, as one who is impatient
 To see what it behoves him to escape,
 And whom a sudden terror doth unman,
Who, while he looks, delays not his departure;
 And I beheld behind us a black devil,
 Running along upon the crag, approach.
Ah, how ferocious was he in his aspect!
 And how he seemed to me in action ruthless,
 With open wings and light upon his feet!
His shoulders, which sharp-pointed were and high,
 A sinner did encumber with both haunches,
 And he held clutched the sinews of the feet.

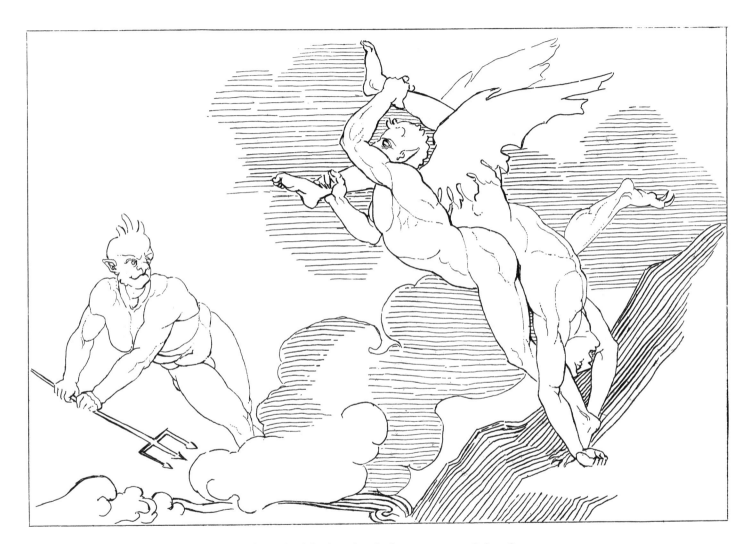

And he held clutched the sinews of the feet

The Bridge
Canto XXI, lines 67–75

With the same fury, and the same uproar,
 As dogs leap out upon a mendicant,
 Who on a sudden begs, where'er he stops,
They issued from beneath the little bridge,
 And turned against him all their grappling-irons;
 But he cried out: "Be none of you malignant!
Before those hooks of yours lay hold of me,
 Let one of you step forward, who may hear me,
 And then take counsel as to grappling me."

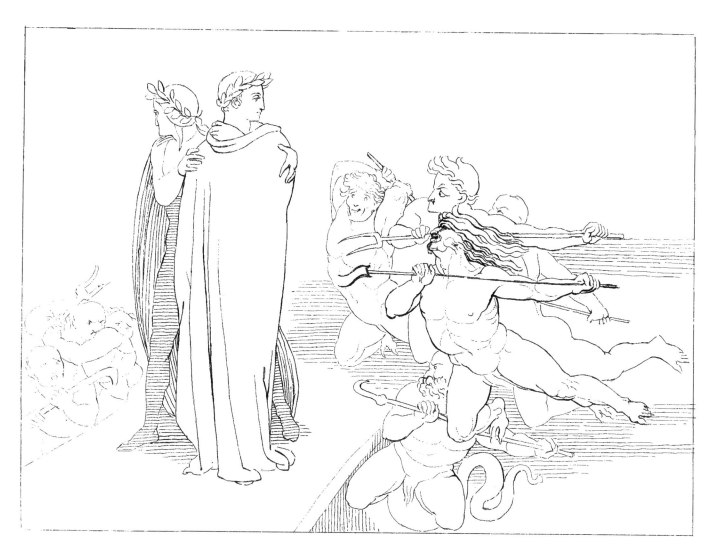

And turned against him all their grappling-irons

The Lake of Pitch
Canto XXII, lines 28–36

So upon every side the sinners stood;
 But ever as Barbariccia near them came,
 Thus underneath the boiling they withdrew.
I saw, and still my heart doth shudder at it,
 One waiting thus, even as it comes to pass
 One frog remains, and down another dives;
And Graffiacan, who most confronted him,
 Grappled him by his tresses smeared with pitch,
 And drew him up, so that he seemed an otter.

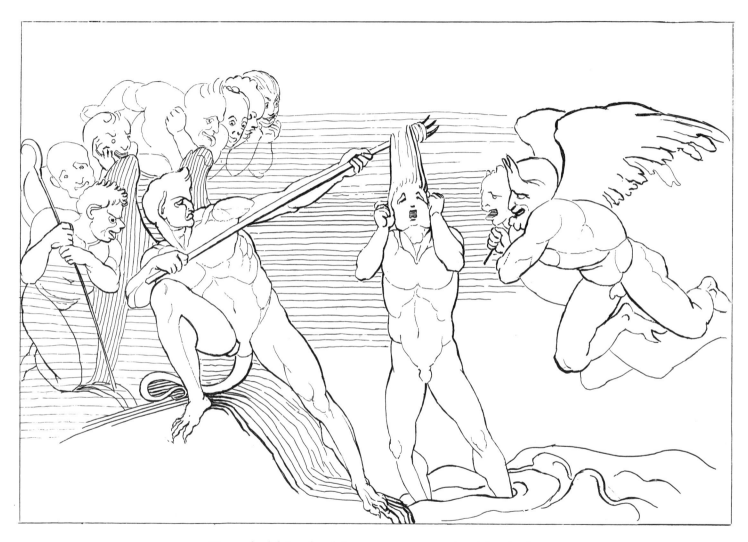

Grappled him by his tresses smeared with pitch

Hypocrites

Canto XXIII, lines 52–60

Hardly the bed of the ravine below
 His feet had reached, ere they had reached the hill
 Right over us; but he was not afraid;
For the high Providence, which had ordained
 To place them ministers of the fifth moat,
 The power of thence departing took from all.
A painted people there below we found,
 Who went about with footsteps very slow,
 Weeping and in their semblance tired and vanquished.

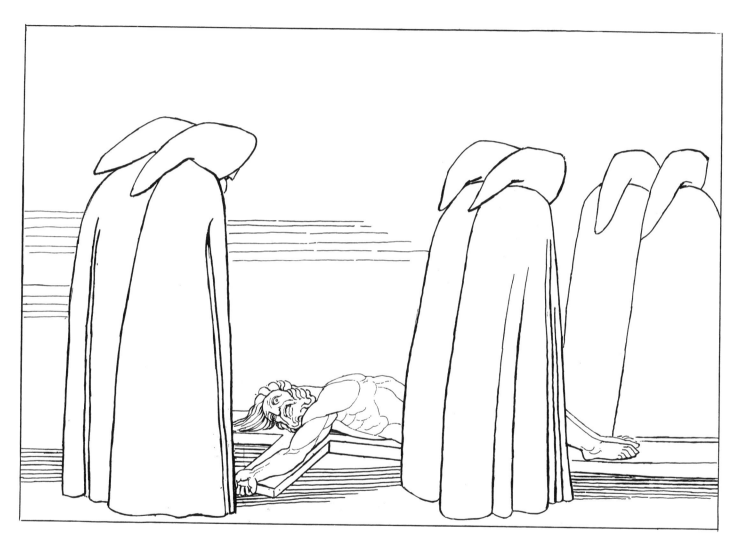

A painted people there below we found

The Fiery Serpents
Canto XXIV, lines 91–99

Among this cruel and most dismal throng
 People were running naked and affrighted.
 Without the hope of hole or heliotrope.
They had their hands with serpents bound behind them;
 These riveted upon their reins the tail
 And head, and were in front of them entwined.
And lo! at one who was upon our side
 There darted forth a serpent, which transfixed him
 There where the neck is knotted to the shoulders.

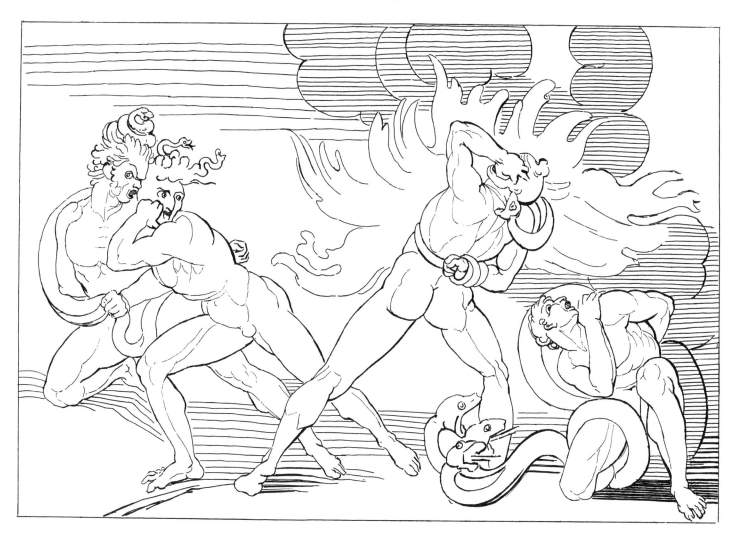

They had their hands with serpents bound behind them

Cacus

Canto XXV, lines 17–24

And I beheld a Centaur full of rage
 Come crying out: "Where is, where is the scoffer?"
I do not think Maremma has so many
 Serpents as he had all along his back,
 As far as where our countenance begins.
Upon the shoulders, just behind the nape,
 With wings wide open was a dragon lying,
 And he sets fire to all that he encounters.

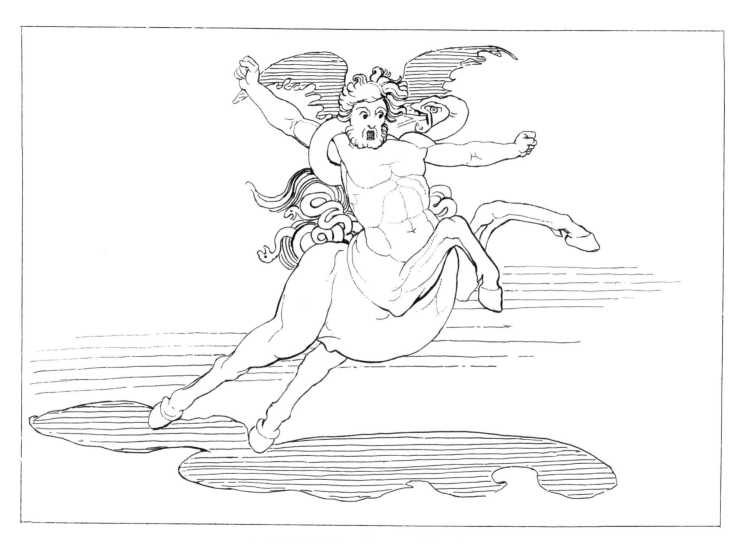

And I beheld a Centaur full of rage

The Flaming Gulph
Canto XXVI, lines 13–18

We went our way, and up along the stairs
The bourns had made us to descend before,
Remounted my Conductor and drew me.
And following the solitary path
Among the rocks and ridges of the crag,
The foot without the hand sped not at all.

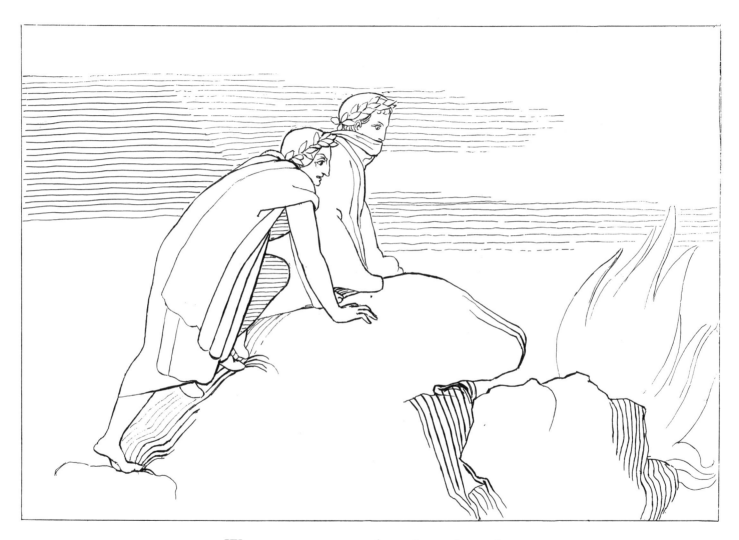

We went our way, and up along the stairs

The Contention for Guido de Montefeltro
Canto XXVII, lines 108–114

And said I: 'Father, since thou washest me
 Of that sin into which I now must fall,
 The promise long with the fulfillment short
 Will make thee triumph in thy lofty seat.'
Francis came afterward, when I was dead,
 For me; but one of the black Cherubim
 Said to him: 'Take him not; do me no wrong;'

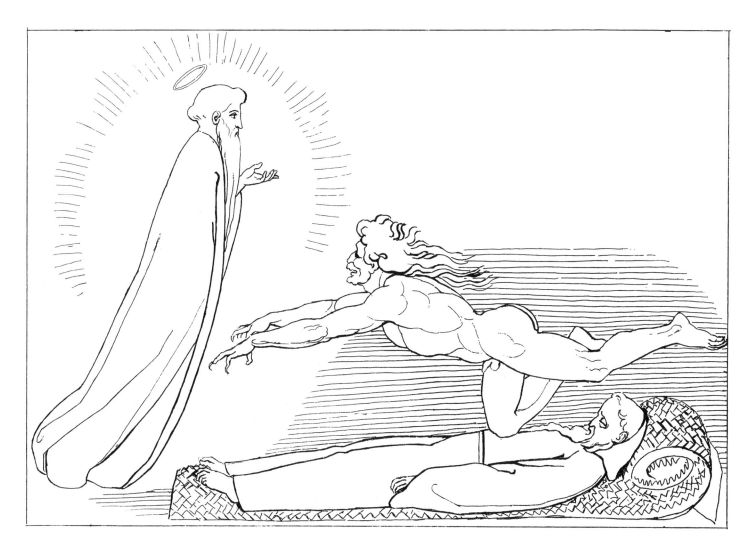

Francis came afterward, when I was dead

The Schismatics

Canto XXVIII, lines 118–123

I truly saw, and still I seem to see it,
 A trunk without a head walk in like manner
 As walked the others of the mournful herd.
And by the hair it held the head dissevered,
 Hung from the hand in fashion of a lantern,
 And that upon us gazed and said: "O me!"

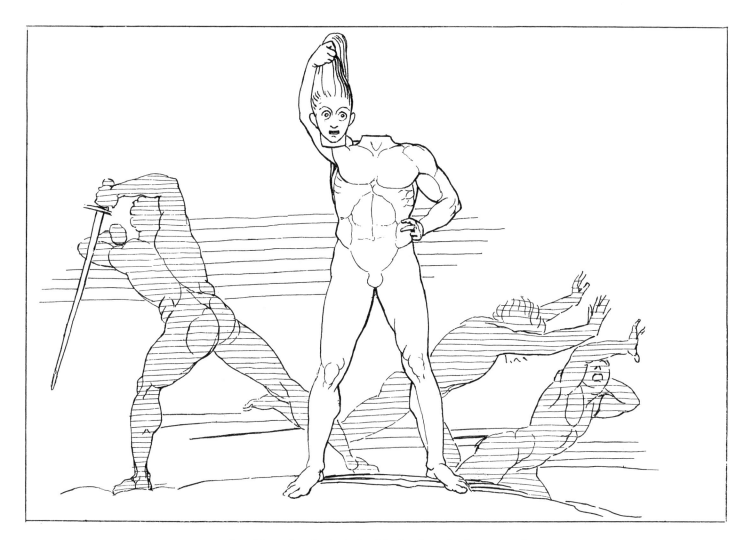

And by the hair it held the head dissevered

The Vale of Disease
Canto XXIX, lines 58–69

I do not think a sadder sight to see
 Was in Ægina the whole people sick,
 (When was the air so full of pestilence,
The animals, down to the little worm,
 All fell, and afterwards the ancient people,
 According as the poets have affirmed,
Were from the seed of ants restored again,)
 Than was it to behold through that dark valley
 The spirits languishing in divers heaps.
This on the belly, that upon the back
 One of the other lay, and others crawling
 Shifted themselves along the dismal road.

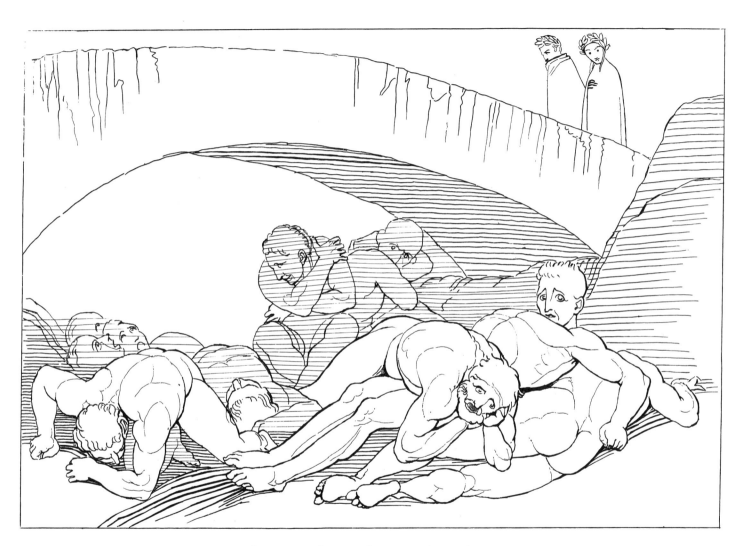

The spirits languishing in divers heaps

Impostors

Canto XXX, lines 25–30

As I beheld two shadows pale and naked,
 Who, biting, in the manner ran along
 That a boar does, when from the sty turned loose.
One to Capocchio came, and by the nape
 Seized with its teeth his neck, so that in dragging
 It made his belly grate the solid bottom.

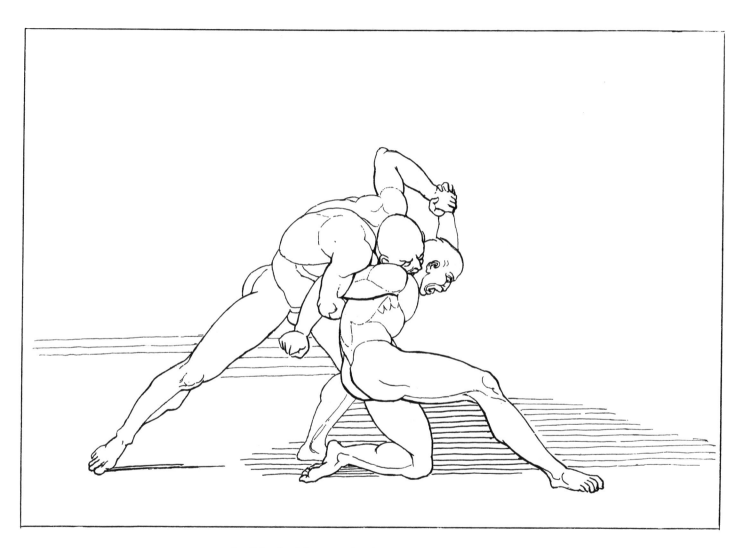

As I beheld two shadows pale and naked

The Giants

Canto XXXI, lines 139–145

Such did Antæus seem to me, who stood
 Watching to see him stoop, and then it was
 I could have wished to go some other way.
But lightly in the abyss, which swallows up
 Judas with Lucifer, he put us down;
 Nor thus bowed downward made he there delay,
But, as a mast does in a ship, uprose.

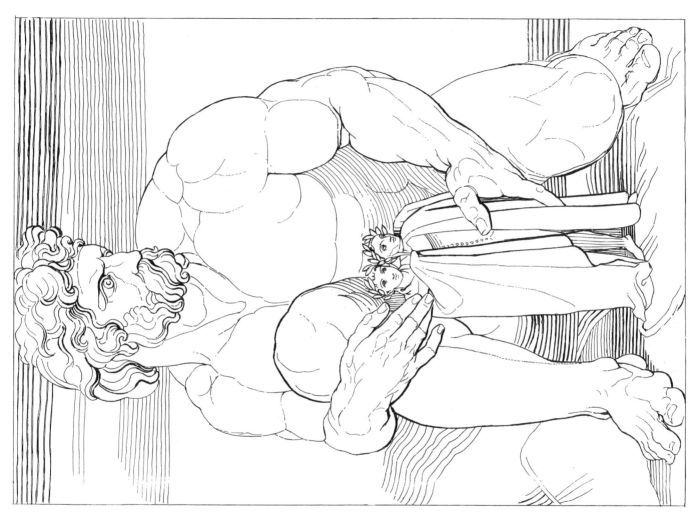

He put us down

The Frozen Lake
Canto XXXII, lines 13–21

Rabble ill-begotten above all,
 Who're in the place to speak of which is hard,
 'Twere better ye had here been sheep or goats!
When we were down within the darksome well,
 Beneath the giant's feet, but lower far,
 And I was scanning still the lofty wall,
I heard it said to me: "Look how thou steppest!
 Take heed thou do not trample with thy feet
 The heads of the tired, miserable brothers!"

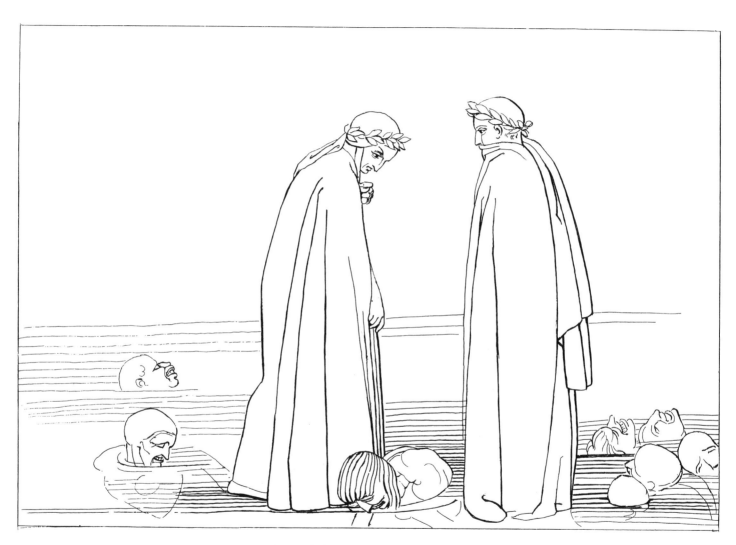

"Look how thou steppest!"

Count Ugolino Seized

Canto XXXIII, lines 13–21

Thou hast to know I was Count Ugolino,
 And this one was Ruggieri the Archbishop;
 Now I will tell thee why I am such a neighbour.
That, by effect of his malicious thoughts,
 Trusting in him I was made prisoner,
 And after put to death, I need not say;
But ne'ertheless what thou canst not have heard,
 That is to say, how cruel was my death,
 Hear shalt thou, and shalt know if he has wronged me.

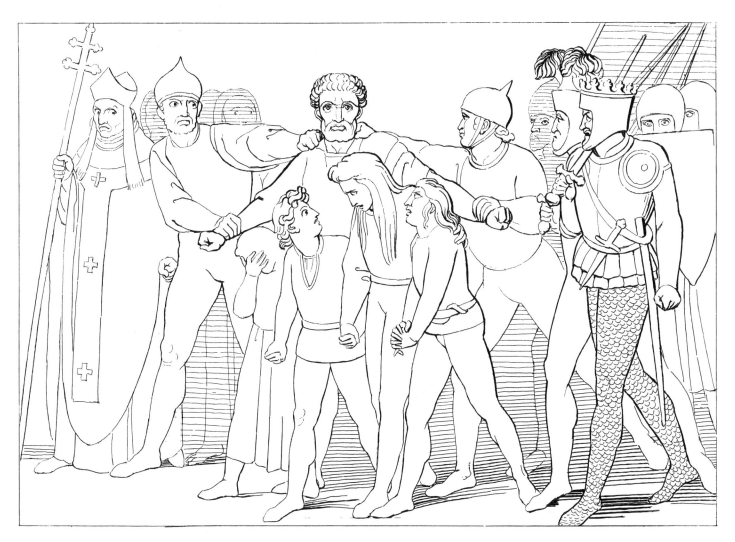

Thou hast to know I was Count Ugolino

The Death of Ugolino
Canto XXXIII, lines 67–75

When we had come unto the fourth day, Gaddo
Threw himself down outstretched before my feet,
Saying, 'My father, why dost thou not help me?'
And there he died; and, as thou seest me,
I saw the three fall, one by one, between
The fifth day and the sixth; whence I betook me,
Already blind, to groping over each,
And three days called them after they were dead;
Then hunger did what sorrow could not do."

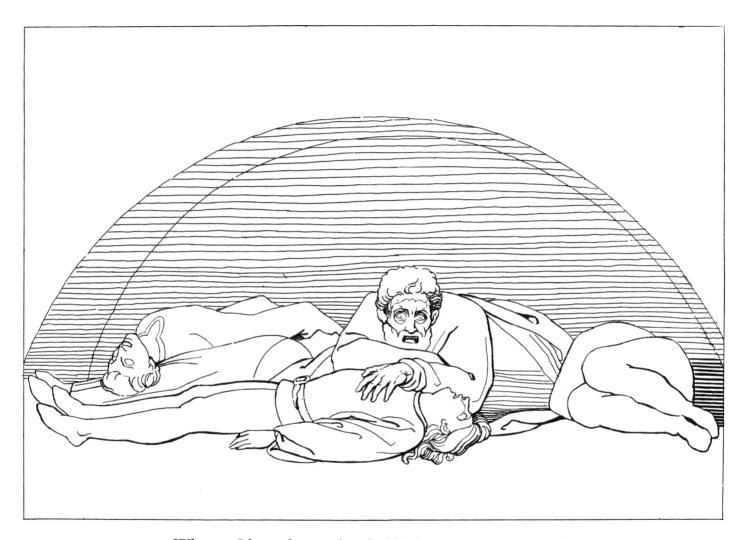

Whence I betook me, already blind, to groping over each

Dis, or Lucifer
Canto XXXIV, lines 25–33

I did not die, and I alive remained not;
 Think for thyself now, hast thou aught of wit,
 What I became, being of both deprived.
The Emperor of the kingdom dolorous
 From his mid-breast forth issued from the ice;
 And better with a giant I compare
Than do the giants with those arms of his;
 Consider now how great must be that whole,
 Which unto such a part conforms itself.

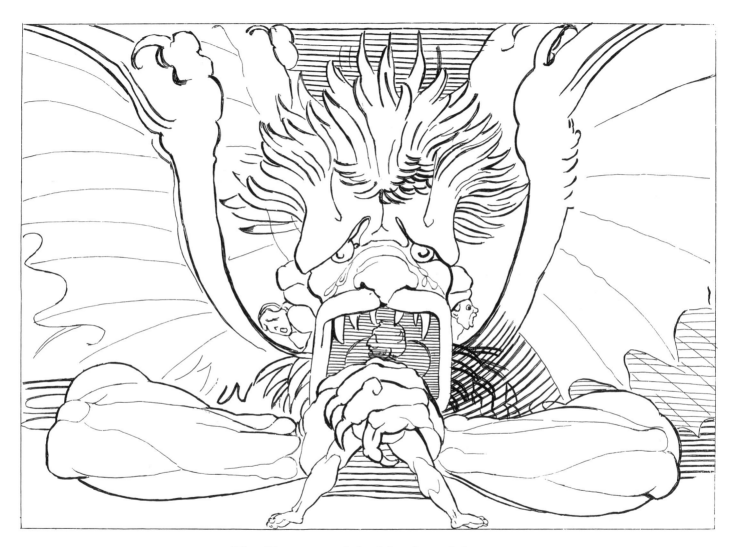

The Emperor of the kingdom dolorous

The Reascent

Canto XXXIV, lines 133–139

The Guide and I into that hidden road
 Now entered, to return to the bright world;
 And without care of having any rest
We mounted up, he first and I the second,
 Till I beheld through a round aperture
 Some of the beauteous things that Heaven doth bear;
Thence we came forth to rebehold the stars.

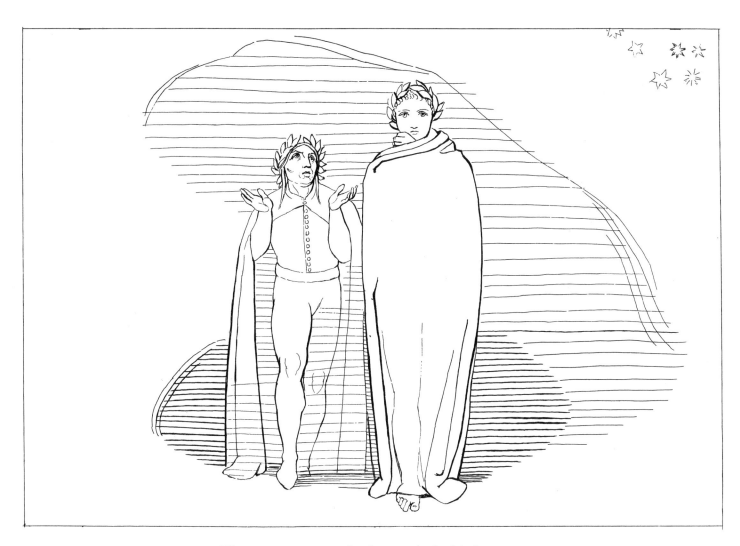

Thence we came forth to rebehold the stars

The Mountain of Probation

Canto I, lines 49–54

Then did my Leader lay his grasp upon me,
 And with his words, and with his hands and signs,
 Reverent he made in me my knees and brow;
Then answered him: "I came not of myself;
 A Lady from Heaven descended, at whose prayers
 I aided this one with my company.

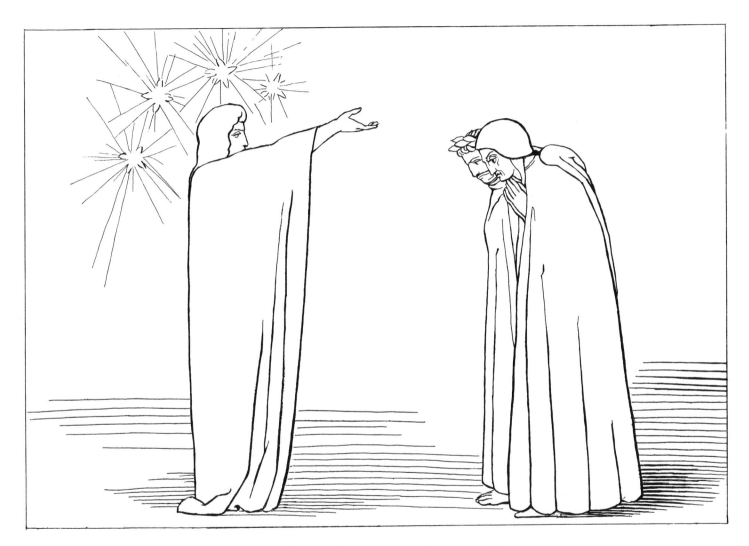

Reverent he made in me my knees and brow

Humiliation

Canto I, lines 130–136

Then came we down upon the desert shore
 Which never yet saw navigate its waters
 Any that afterward had known return.
There he begirt me as the other pleased;
 O marvellous! for even as he culled
 The humble plant, such it sprang up again
Suddenly there where he uprooted it.

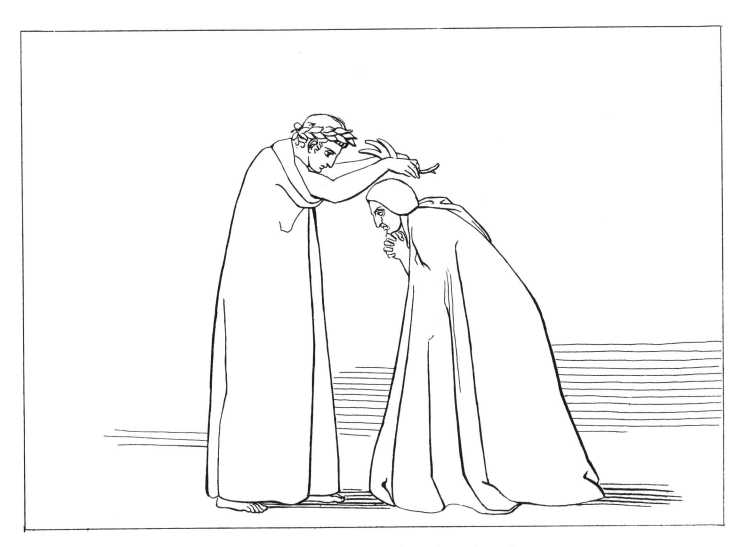

There he begirt me as the other pleased

The Bark of Purgatory
Canto II, lines 25–30

My Master yet had uttered not a word
While the first whiteness into wings unfolded;
But when he clearly recognised the pilot,
He cried: "Make haste, make haste to bow the knee!
Behold the Angel of God! fold thou thy hands!
Henceforward shalt thou see such officers!

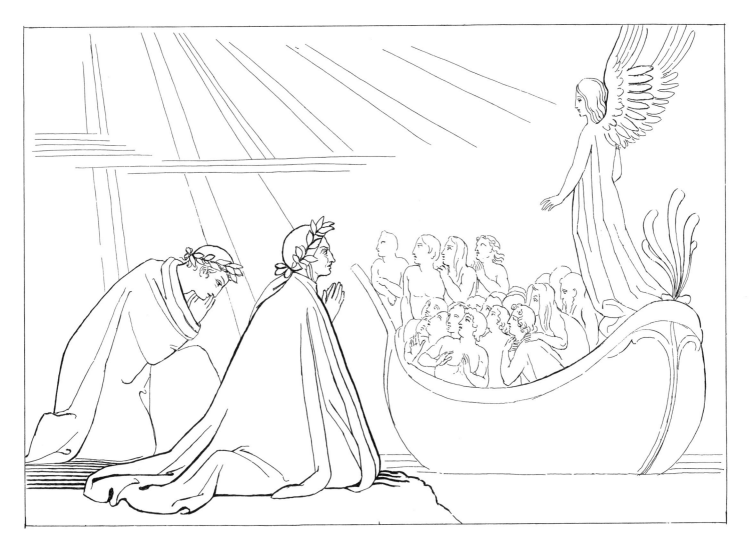

"Behold the Angel of God!"

The Benediction
Canto II, lines 43–51

Upon the stern stood the Celestial Pilot;
 Beatitude seemed written in his face,
 And more than a hundred spirits sat within.
"*In exitu Israel de Ægypto!*"
 They chanted all together in one voice,
 With whatso in that psalm is after written.
Then made he sign of holy rood upon them,
 Whereat all cast themselves upon the shore,
 And he departed swiftly as he came.

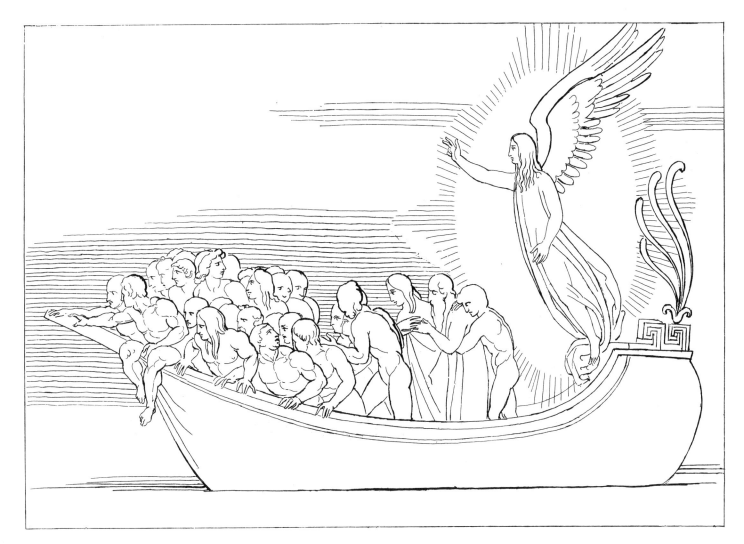

Upon the stern stood the Celestial Pilot

Casella's Song
Canto II, lines 112–117

Love, that within my mind discourses with me,"
 Forthwith began he so melodiously,
 The melody within me still is sounding.
My Master, and myself, and all that people
 Which with him were, appeared as satisfied
 As if naught else might touch the mind of any.

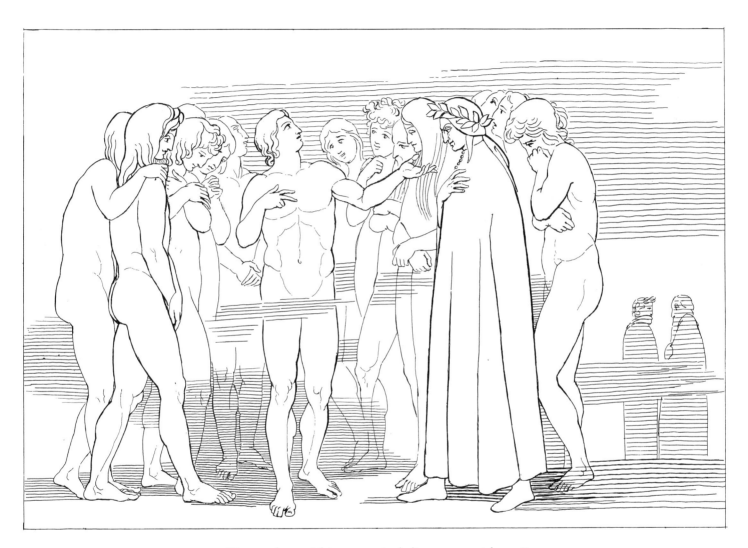

"Love, that within my mind discourses with me"

The Vestibule of Purgatory
Canto III, lines 85–93

So moving to approach us thereupon
 I saw the leader of that fortunate flock,
 Modest in face and dignified in gait.
As soon as those in the advance saw broken
 The light upon the ground at my right side,
 So that from me the shadow reached the rock,
They stopped, and backward drew themselves somewhat;
 And all the others, who came after them,
 Not knowing why nor wherefore, did the same.

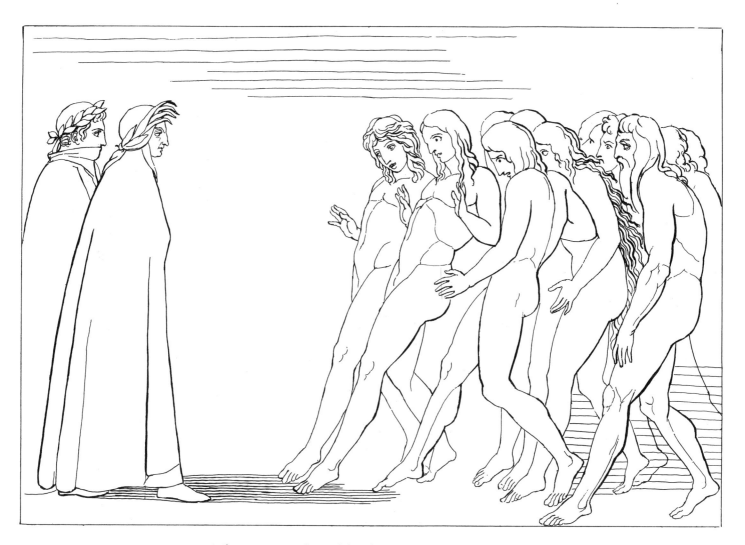

They stopped, and backward drew themselves

The Negligent

Canto IV, lines 103–108

Thither we drew; and there were persons there
Who in the shadow stood behind the rock,
As one through indolence is wont to stand.
And one of them, who seemed to me fatigued,
Was sitting down, and both his knees embraced,
Holding his face low down between them bowed.

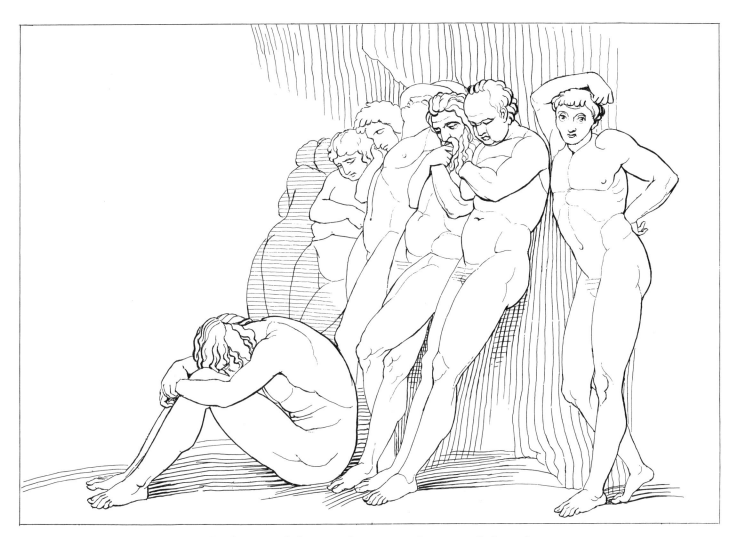

And one of them, who seemed to me fatigued,
was sitting down, and both his knees embraced

The Deliverance of Buonaconti
Canto V, lines 103–108

Truth will I speak, repeat it to the living;
 God's Angel took me up, and he of hell
 Shouted: 'O thou from heaven, why dost thou rob me?
Thou bearest away the eternal part of him,
 For one poor little tear, that takes him from me;
 But with the rest I'll deal in other fashion!'

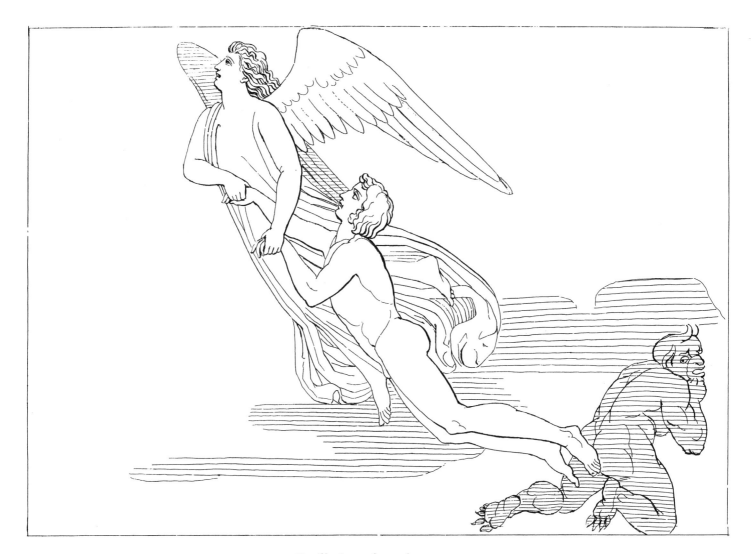

God's Angel took me up

The Meeting with Sordello
Canto VI, lines 67–75

Still near to it Virgilius drew, entreating
 That it would point us out the best ascent;
 And it replied not unto his demand,
But of our native land and of our life
 It questioned us; and the sweet Guide began:
 "Mantua,"—and the shade, all in itself recluse,
Rose tow'rds him from the place where first it was,
 Saying: "O Mantuan, I am Sordello
 Of thine own land!" and one embraced the other.

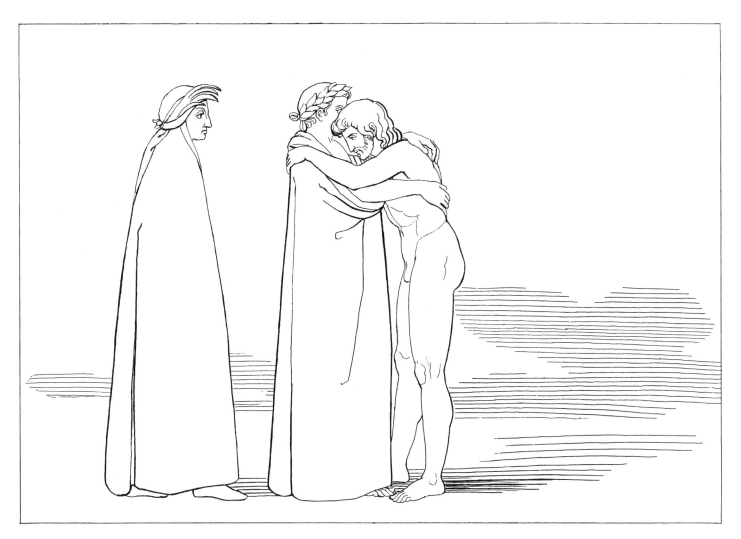

"O Mantuan, I am Sordello"

Limbo

Canto VII, lines 28–33

A place there is below not sad with torments,
But darkness only, where the lamentations
Have not the sound of wailing, but are sighs.
There dwell I with the little innocents
Snatched by the teeth of Death, or ever they
Were from our human sinfulness exempt.

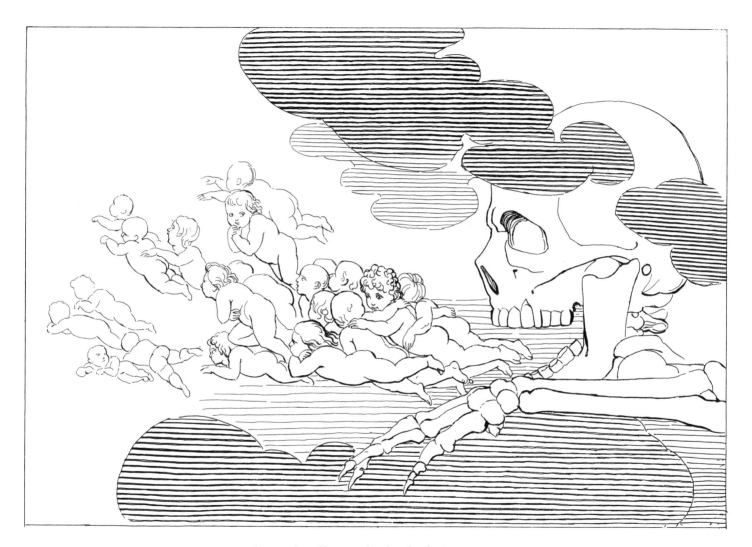

There dwell I with the little innocents

The Valley

Canto VIII, lines 25–30

And from on high come forth and down descend,
 I saw two Angels with two flaming swords,
 Truncated and deprivëd of their points.
 Green as the little leaflets just now born
 Their garments were, which, by their verdant pinions
 Beaten and blown abroad, they trailed behind.

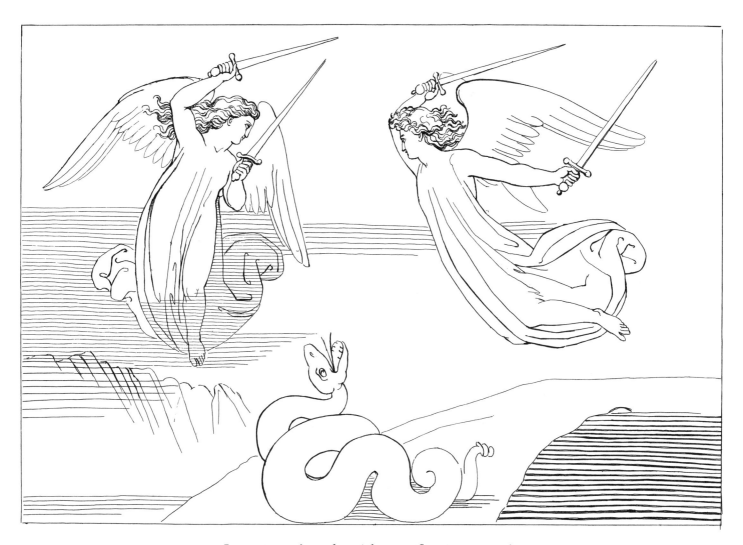

I saw two Angels with two flaming swords

Dante's Dream

Canto IX, lines 28–33

Then wheeling somewhat more, it seemed to me,
 Terrible as the lightning he descended,
 And snatched me upward even to the fire.
Therein it seemed that he and I were burning,
 And the imagined fire did scorch me so,
That of necessity my sleep was broken.

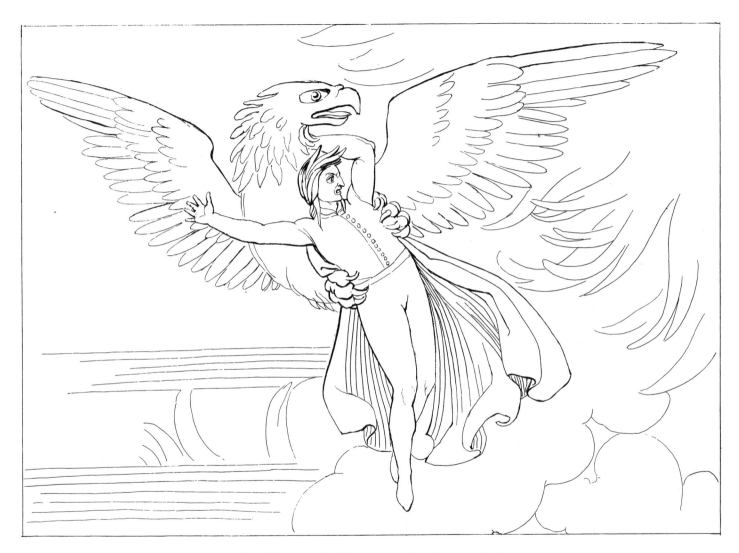

Terrible as the lightning he descended,
and snatched me upward even to the fire

Gate of Purgatory
Canto IX, lines 130–138

Then pushed the portals of the sacred door,
 Exclaiming: "Enter; but I give you warning
 That forth returns whoever looks behind."
And when upon their hinges were turned round
 The swivels of that consecrated gate,
 Which are of metal, massive and sonorous,
Roared not so loud, nor so discordant seemed
 Tarpeia, when was ta'en from it the good
 Metellus, wherefore meagre it remained.

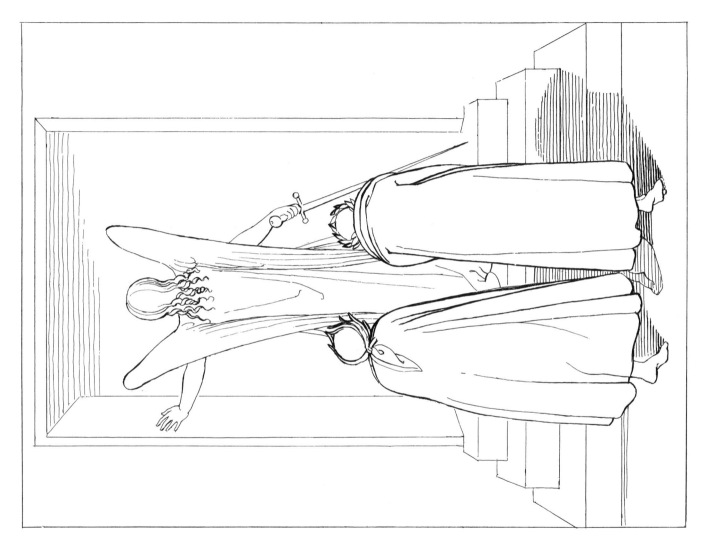

"Enter; but I give you warning
that forth returns whoever looks behind."

The Salutation
Canto X, lines 34–40

The Angel, who came down to earth with tidings
 Of peace, that had been wept for many a year,
 And opened Heaven from its long interdict,
In front of us appeared so truthfully
 There sculptured in a gracious attitude,
 He did not seem an image that is silent.
One would have sworn that he was saying, *"Ave"*

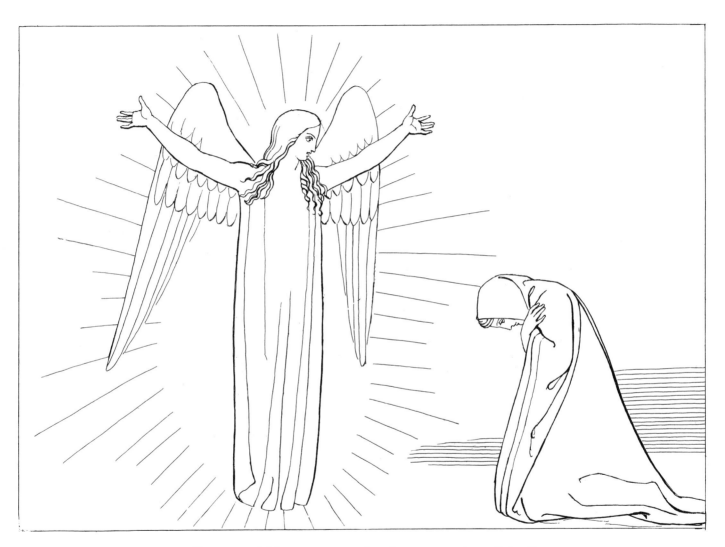

One would have sworn that he was saying, *"Ave"*

The Proud

Canto XI, lines 22–30

This last petition verily, dear Lord,
　　Not for ourselves is made, who need it not,
　　But for their sake who have remained behind us."
Thus for themselves and us good furtherance
　　Those shades imploring, went beneath a weight
　　Like unto that of which we sometimes dream,
Unequally in anguish round and round
　　And weary all, upon that foremost cornice,
　　Purging away the smoke-stains of the world.

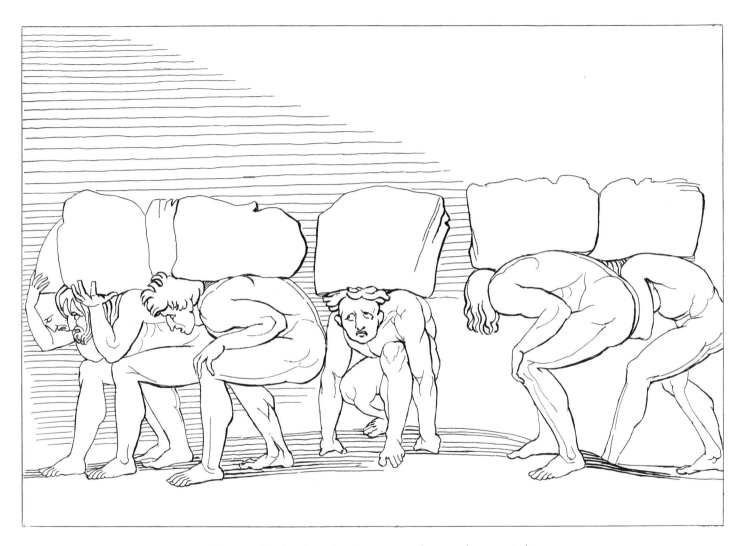

Those shades imploring, went beneath a weight

Lucifer

Canto XII, lines 25–27

I saw that one who was created noble
More than all other creatures, down from heaven
Flaming with lightnings fall upon one side.

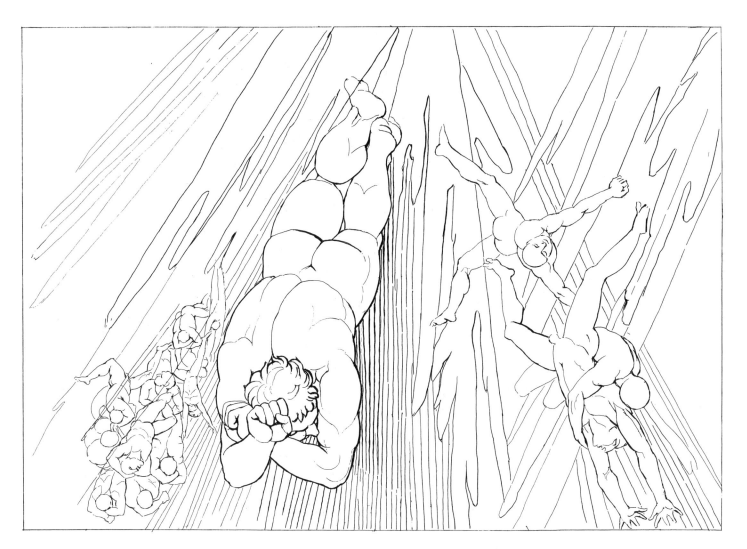

I saw that one who was created noble

Purification from Envy
Canto XIII, lines 22–27

As much as here is counted for a mile,
So much already there had we advanced
In little time, by dint of ready will;
And tow'rds us there were heard to fly, albeit
They were not visible, spirits uttering
Unto Love's table courteous invitations

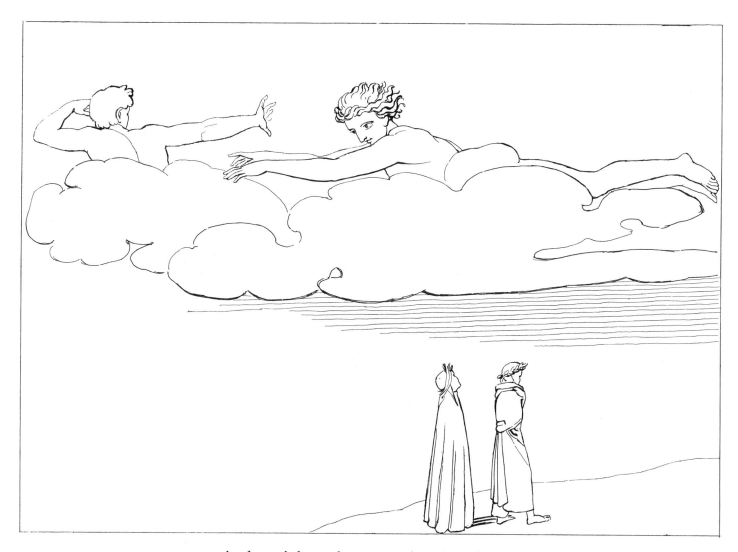

And tow'rds us there were heard to fly . . .
spirits uttering unto Love's table courteous invitations

A Conversation with Guido di Brettinoro
Canto XIV, lines 7–15

Thus did two spirits, leaning tow'rds each other,
 Discourse about me there on the right hand;
Then held supine their faces to address me.
And said the one: "O soul, that, fastened still
 Within the body, tow'rds the heaven art going,
 For charity console us, and declare
Whence comest and who art thou; for thou mak'st us
 As much to marvel at this grace of thine
 As must a thing that never yet has been."

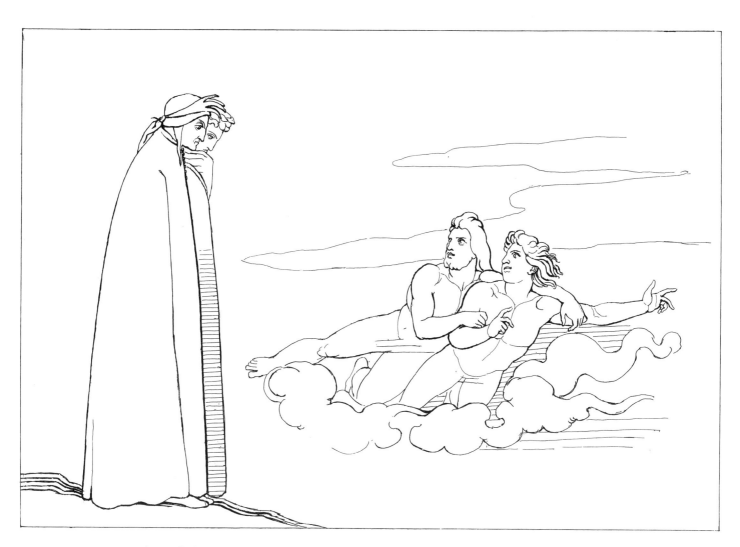

Thus did two spirits, leaning tow'rds each other, discourse about me

Conducted by an Angel
Canto XV, lines 30–36

An angel 'tis, who comes to invite us upward.
 Soon will it be, that to behold these things
Shall not be grievous, but delightful to thee
As much as nature fashioned thee to feel."
When we had reached the Angel benedight,
 With joyful voice he said: "Here enter in
To stairway far less steep than are the others."

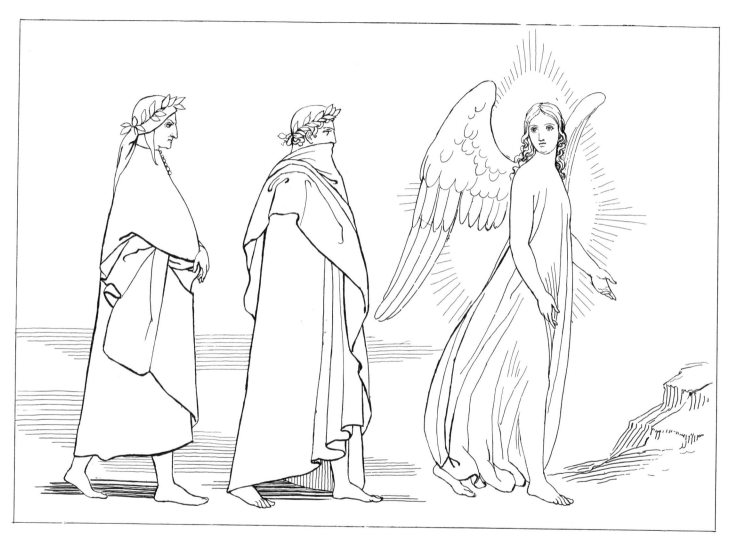

With joyful voice he said: "Here enter in to stairway far less steep than are the others."

The Region of Smoke
Canto XVI, lines 1–9

Darkness of hell, and of a night deprived
 Of every planet under a poor sky,
 As much as may be tenebrous with cloud,
Ne'er made unto my sight so thick a veil,
 As did that smoke which there enveloped us,
 Nor to the feeling of so rough a texture;
For not an eye it suffered to stay open;
 Whereat mine escort, faithful and sagacious,
 Drew near to me and offered me his shoulder.

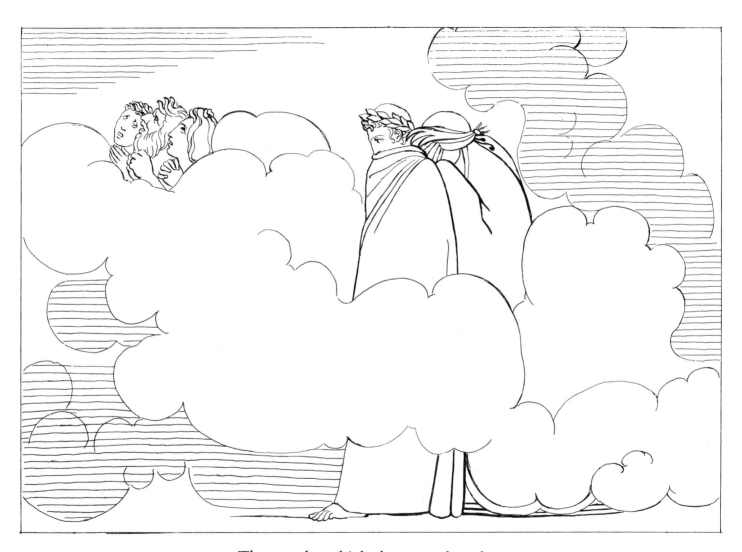

That smoke which there enveloped us

The Choir

Canto XVII, lines 64–69

Thus my Conductor said; and I and he
 Together turned our footsteps to a stairway;
 And I, as soon as the first step I reached,
Near me perceived a motion as of wings,
 And fanning in the face, and saying, "*Beati
Pacifici,* who are without ill anger."

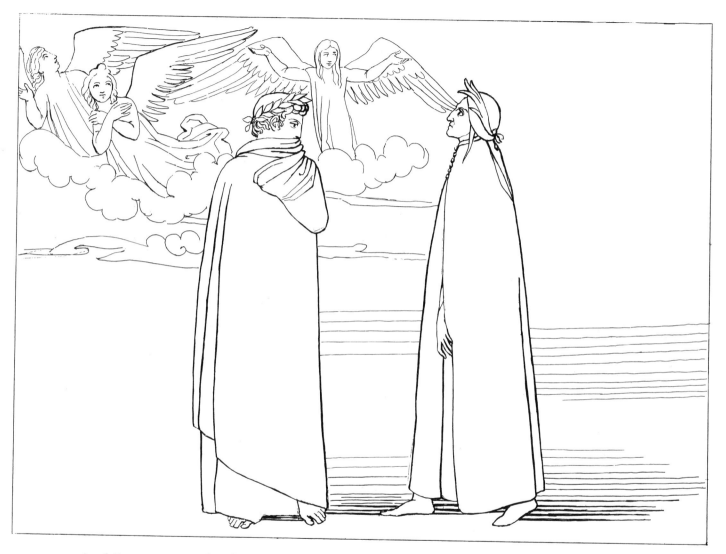

And I, as soon as the first step I reached, near me perceived a motion as of wings

The Region of Selfishness

Canto XVIII, lines 97–102

Full soon they were upon us, because running
 Moved onward all that mighty multitude,
 And two in the advance cried out, lamenting,
"Mary in haste unto the mountain ran,
 And Cæsar, that he might subdue Ilerda,
Thrust at Marseilles, and then ran into Spain."

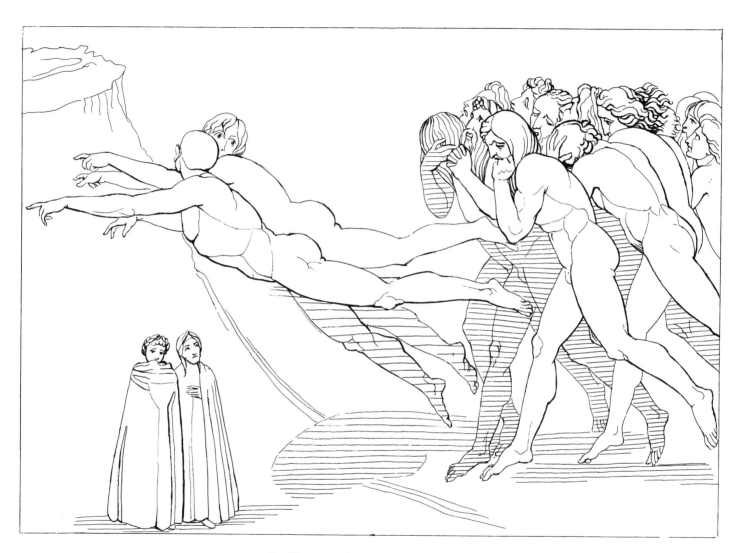

Full soon they were upon us

Region of Avarice
Canto XIX, lines 70–75

On the fifth circle when I had come forth,
 People I saw upon it who were weeping,
 Stretched prone upon the ground, all downward turned.
"Adhæsit pavimento anima mea,"
 I heard them say with sighings so profound,
 That hardly could the words be understood.

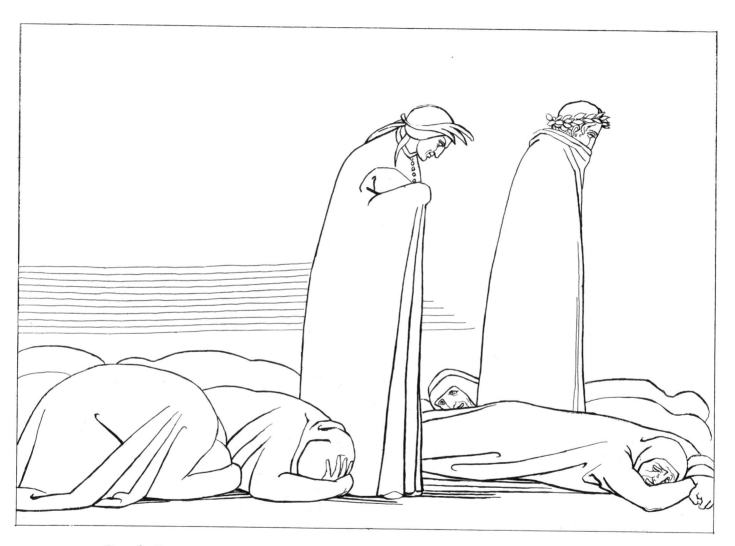

People I saw upon it who were weeping, stretched prone upon the ground

The Earthquake

Canto XX, lines 133–138

Then upon all sides there began a cry,
Such that the Master drew himself towards me,
Saying, "Fear not, while I am guiding thee."
"Gloria in excelsis Deo," all
Were saying, from what near I comprehended,
Where it was possible to hear the cry.

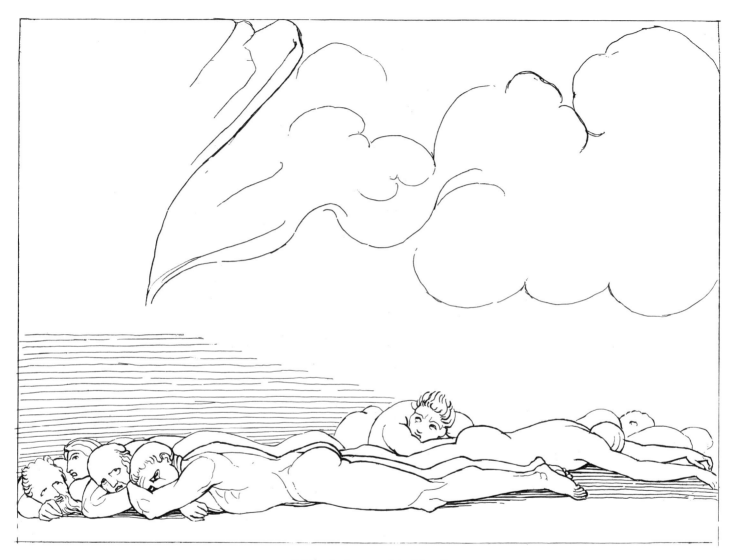

"Gloria in excelsis Deo"

The Meeting with Statius
Canto XXI, lines 25–33

But because she who spinneth day and night
 For him had not yet drawn the distaff off,
 Which Clotho lays for each one and compacts,
His soul, which is thy sister and my own,
 In coming upwards could not come alone,
 By reason that it sees not in our fashion.
Whence I was drawn from out the ample throat
 Of Hell to be his guide, and I shall guide him
 As far on as my school has power to lead.

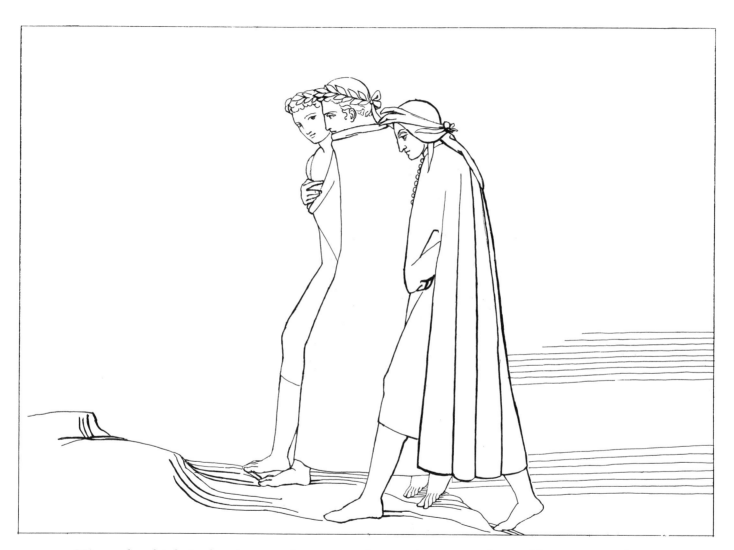

His soul, which is thy sister and my own, in coming upwards could not come alone

Region of Intemperance

Canto XXII, lines 127–132

They in advance went on, and I alone
　　Behind them, and I listened to their speech,
　　Which gave me lessons in the art of song.
But soon their sweet discourses interrupted
　　A tree which midway in the road we found,
　　With apples sweet and grateful to the smell.

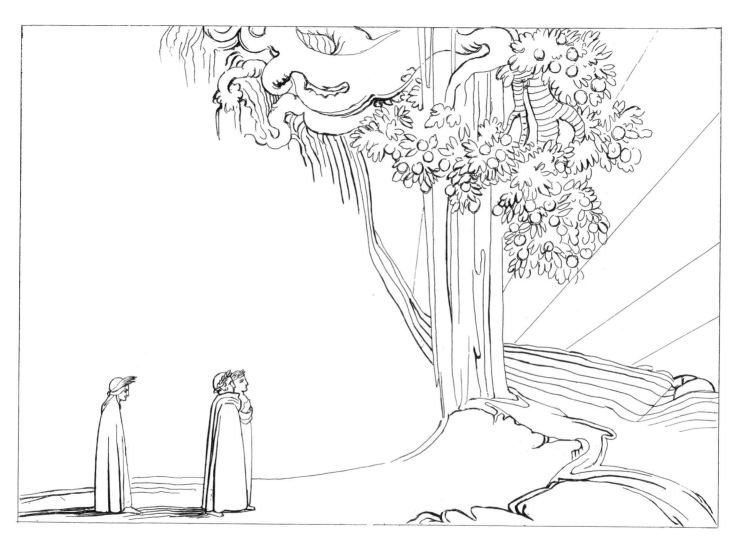

A tree which midway in the road we found, with apples sweet and grateful to the smell

Forese's Elevation
Canto XXIII, lines 82–90

How hast thou come up hitherward already?
 I thought to find thee down there underneath,
 Where time for time doth restitution make."
And he to me: "Thus speedily has led me
 To drink of the sweet wormwood of these torments,
 My Nella with her overflowing tears;
She with her prayers devout and with her sighs
 Has drawn me from the coast where one awaits,
 And from the other circles set me free.

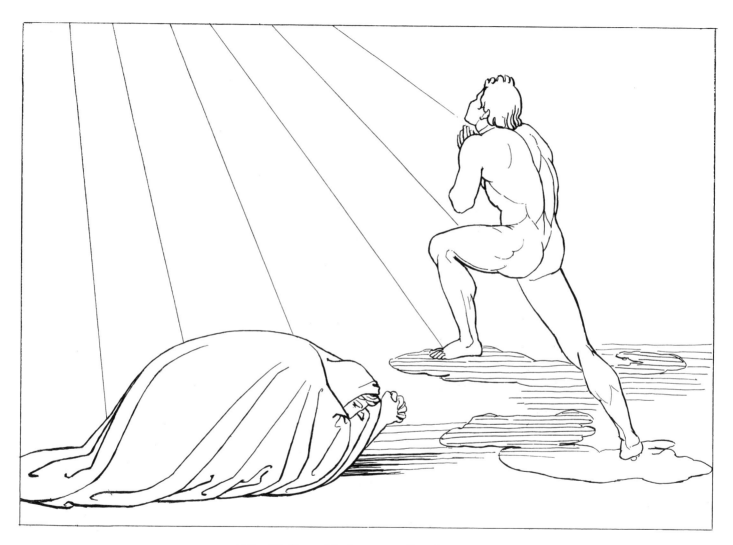

My Nella with her overflowing tears

The Intemperate

Canto XXIV, lines 103–111

Appeared to me with laden and living boughs
 Another apple-tree, and not far distant,
 From having but just then turned thitherward.
People I saw beneath it lift their hands,
 And cry I know not what towards the leaves,
 Like little children eager and deluded,
Who pray, and he they pray to doth not answer,
 But, to make very keen their appetite,
 Holds their desire aloft, and hides it not.

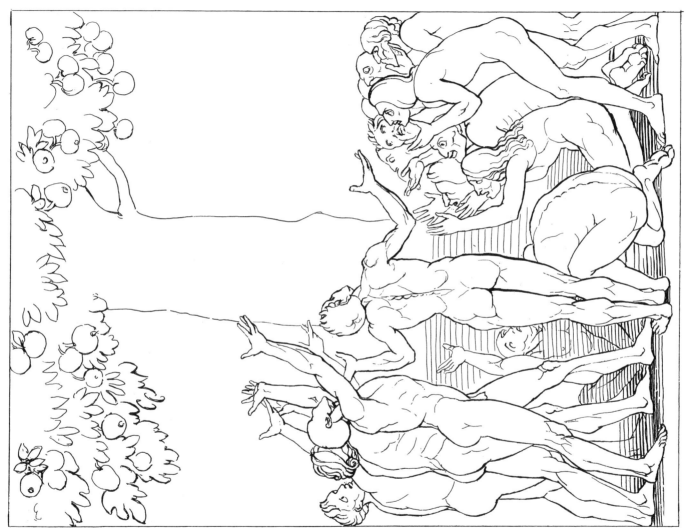

People I saw beneath it lift their hands, and cry I know not what towards the leaves

The Carnal

Canto XXV, lines 118–126

My Leader said: "Along this place one ought
To keep upon the eyes a tightened rein,
Seeing that one so easily might err."
"Summæ Deus clementiæ," in the bosom
Of the great burning chanted then I heard,
Which made me no less eager to turn round;
And spirits saw I walking through the flame;
Wherefore I looked, to my own steps and theirs
Apportioning my sight from time to time.

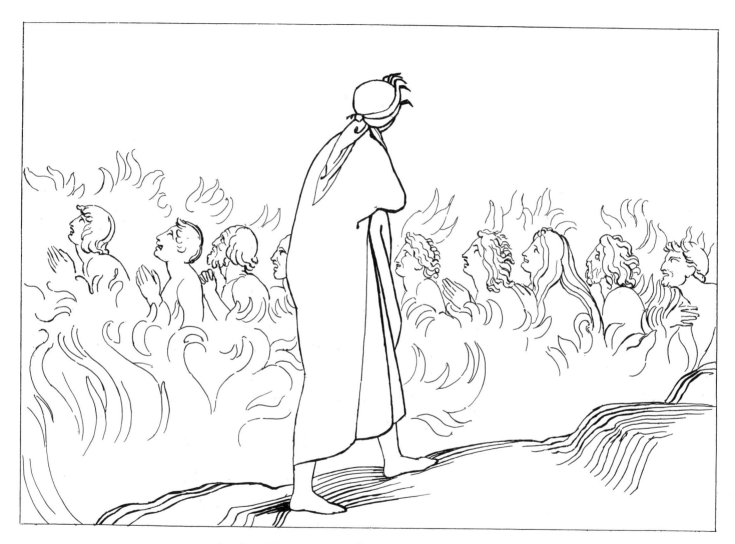

And spirits saw I walking through the flame

The Fiery Doom
Canto XXVI, lines 28–33

For through the middle of the burning road
 There came a people face to face with these,
 Which held me in suspense with gazing at them.
There see I hastening upon either side
 Each of the shades, and kissing one another
 Without a pause, content with brief salute.

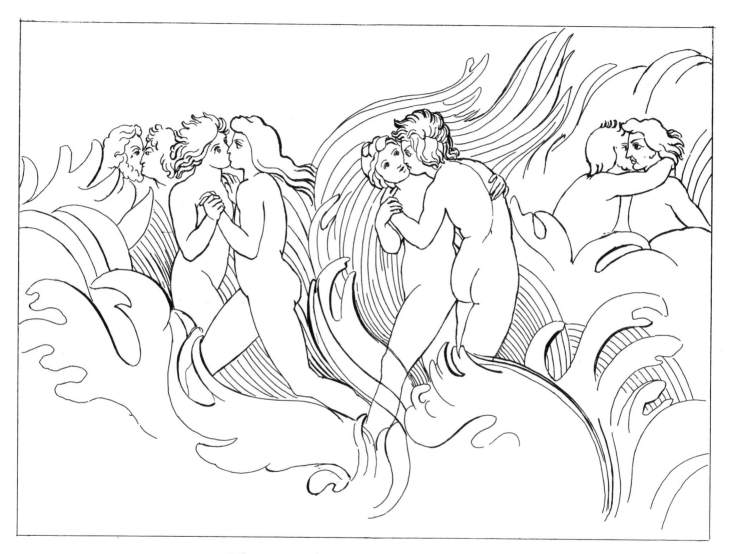

There see I hastening upon either side
each of the shades, and kissing one another

The Poets Reposing
Canto XXVII, lines 70–75

And ere in all its parts immeasurable
The horizon of one aspect had become,
And Night her boundless dispensation held,
Each of us of a stair had made his bed;
Because the nature of the mount took from us
The power of climbing, more than the delight.

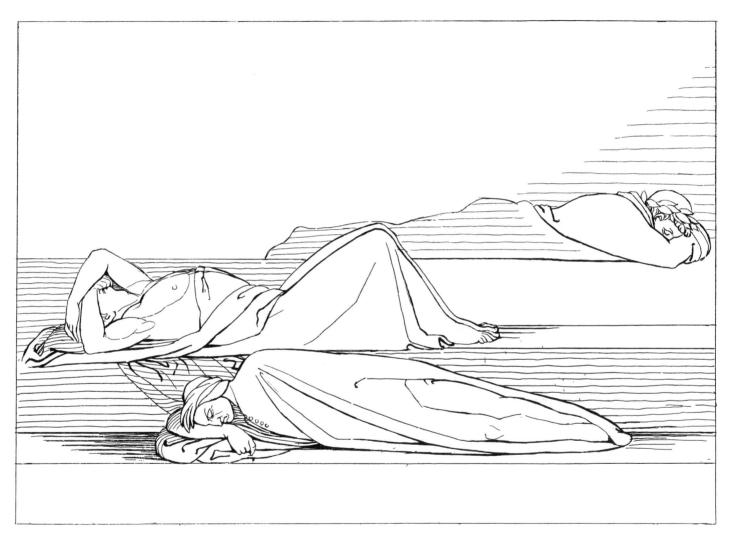

Each of us of a stair had made his bed

Matilda

Canto XXVIII, lines 37–42

And there appeared to me (even as appears
Suddenly something that doth turn aside
Through very wonder every other thought)
A lady all alone, who went along
Singing and culling floweret after floweret,
With which her pathway was all painted over.

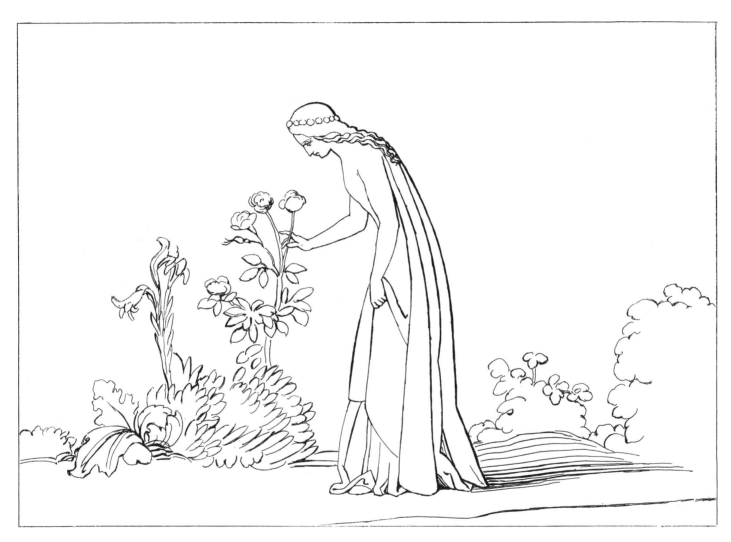

A lady all alone, who went along
singing and culling floweret after floweret

The Procession of Elders
Canto XXIX, lines 82–87

nder so fair a heaven as I describe
The four and twenty Elders, two by two,
Came on incoronate with flower-de-luce.
They all of them were singing: "Blessed thou
Among the daughters of Adam art, and blessed
For evermore shall be thy loveliness."

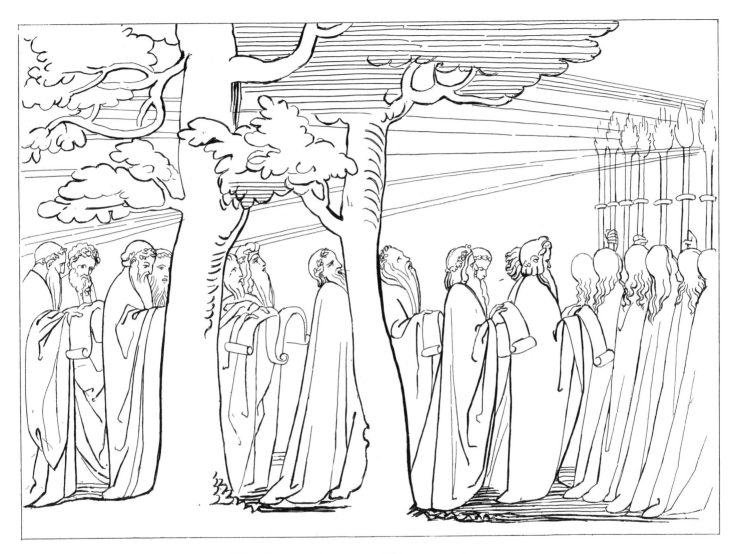

The four and twenty Elders, two by two

The Descent of Beatrice

Canto XXX, lines 49–57

But us Virgilius of himself deprived
 Had left, Virgilius, sweetest of all fathers,
 Virgilius, to whom I for safety gave me:
Nor whatsoever lost the ancient mother
 Availed my cheeks now purified from dew,
 That weeping they should not again be darkened.
"Dante, because Virgilius has departed
 Do not weep yet, do not weep yet awhile;
 For by another sword thou need'st must weep."

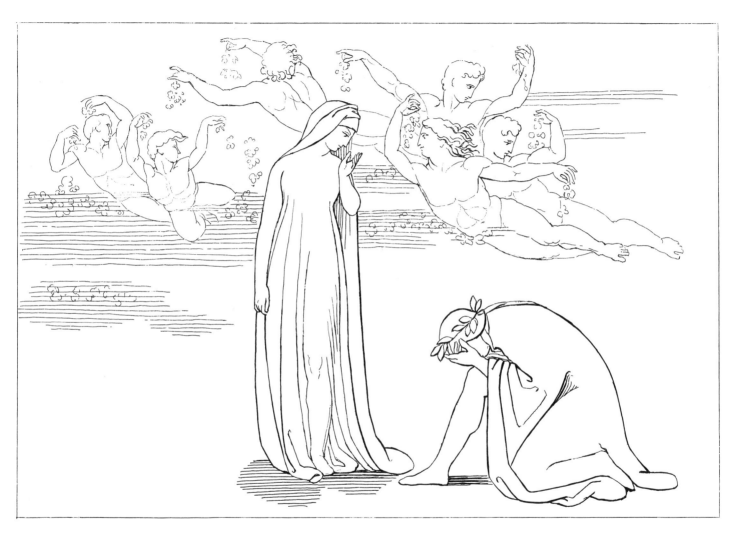

"Do not weep yet, do not weep yet awhile"

The Mysterious Car

Canto XXXI, lines 76–81

And as my countenance was lifted up,
Mine eye perceived those creatures beautiful
Had rested from the strewing of the flowers;
And, still but little reassured, mine eyes
Saw Beatrice turned round towards the monster,
That is one person only in two natures.

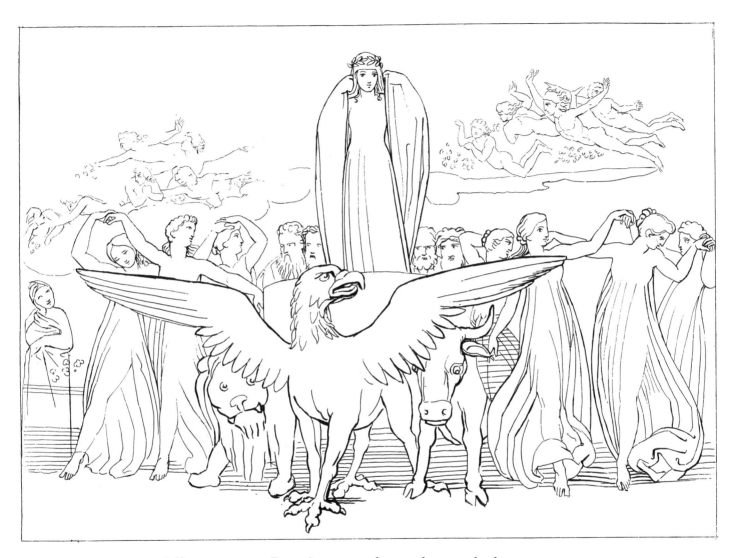

Mine eyes saw Beatrice turned round towards the monster

The River Lethe

Canto XXXI, lines 97–102

When I was near unto the blessed shore,
 "Asperges me," I heard so sweetly sung,
 Remember it I cannot, much less write it.
The beautiful lady opened wide her arms,
 Embraced my head, and plunged me underneath,
 Where I was forced to swallow of the water.

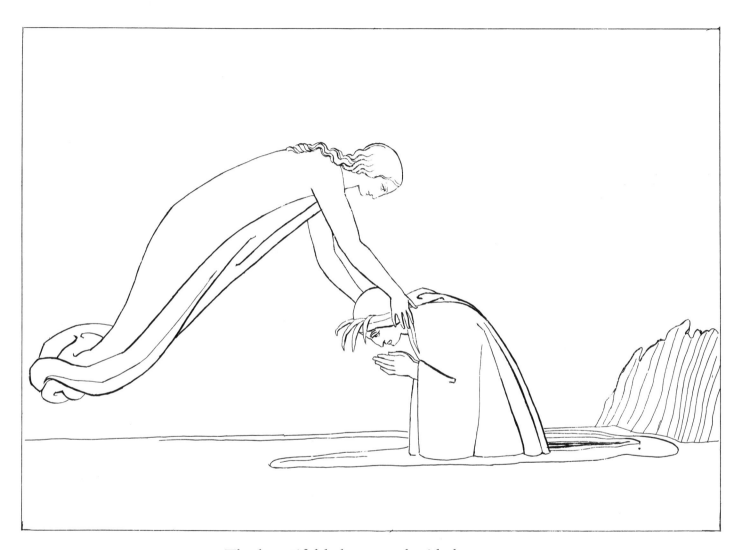

The beautiful lady opened wide her arms,
embraced my head, and plunged me underneath

The Intrigues of the Church
Canto XXXII, lines 148–153

Firm as a rock upon a mountain high,
 Seated upon it, there appeared to me
 A shameless whore, with eyes swift glancing round,
And, as if not to have her taken from him,
 Upright beside her I beheld a giant;
 And ever and anon they kissed each other.

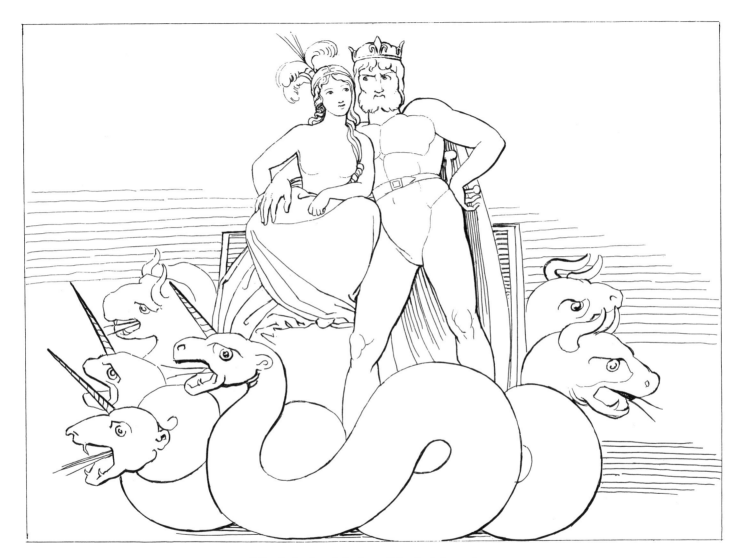

Upright beside her I beheld a giant

The River Eunoë

Canto XXXIII, lines 124–129

And Beatrice: "Perhaps a greater care,
 Which oftentimes our memory takes away,
 Has made the vision of his mind obscure.
But Eunoë behold, that yonder rises;
 Lead him to it, and, as thou art accustomed,
Revive again the half-dead virtue in him."

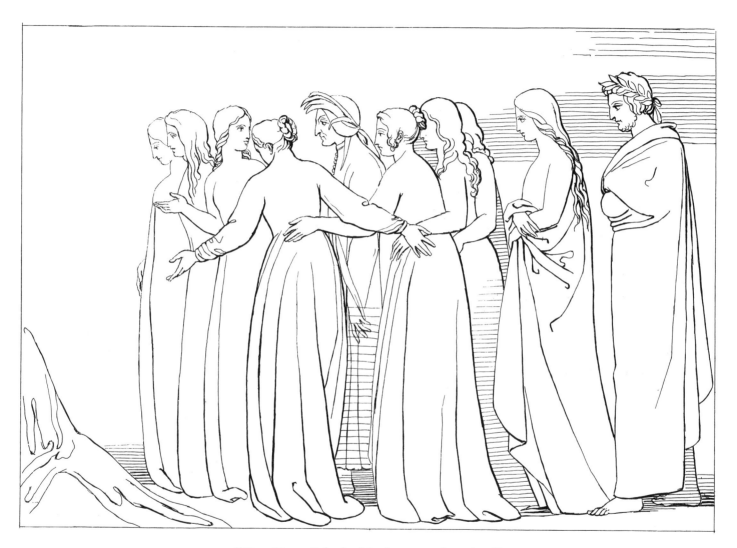

"But Eunoë behold, that yonder rises"

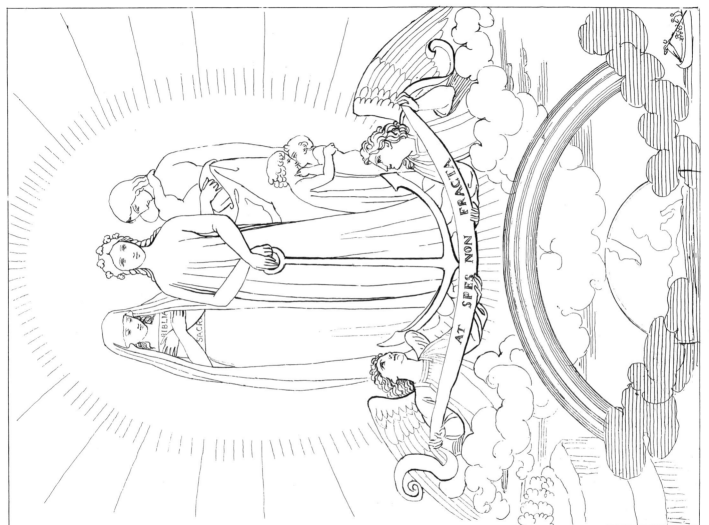

Ascent to the First Heaven
Canto I, lines 61–66

And suddenly it seemed that day to day
 Was added, as if He who has the power
 Had with another sun the heaven adorned.
With eyes upon the everlasting wheels
 Stood Beatrice all intent, and I, on her
 Fixing my vision from above removed

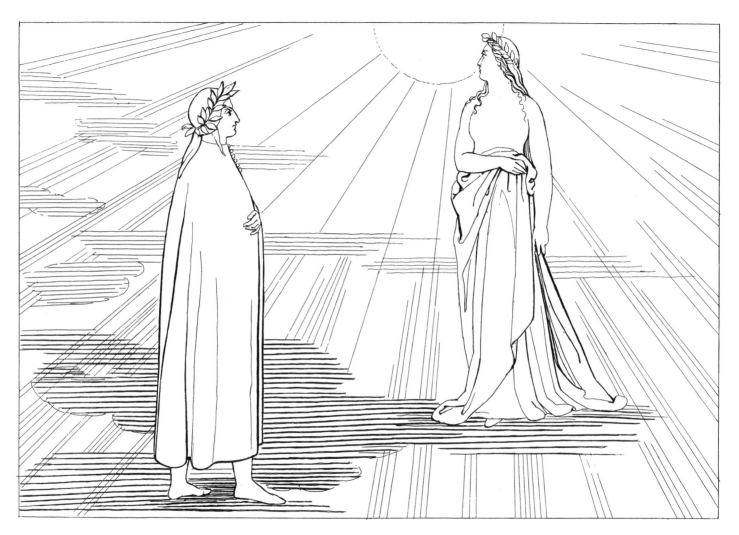

With eyes upon the everlasting wheels
stood Beatrice all intent

The Lunar Sphere
Canto II, lines 22–30

pward gazed Beatrice, and I at her;
 And in such space perchance as strikes a bolt
 And flies, and from the notch unlocks itself,
Arrived I saw me where a wondrous thing
 Drew to itself my sight; and therefore she
 From whom no care of mine could be concealed,
Towards me turning, blithe as beautiful,
 Said unto me: "Fix gratefully thy mind
 On God, who unto the first star has brought us."

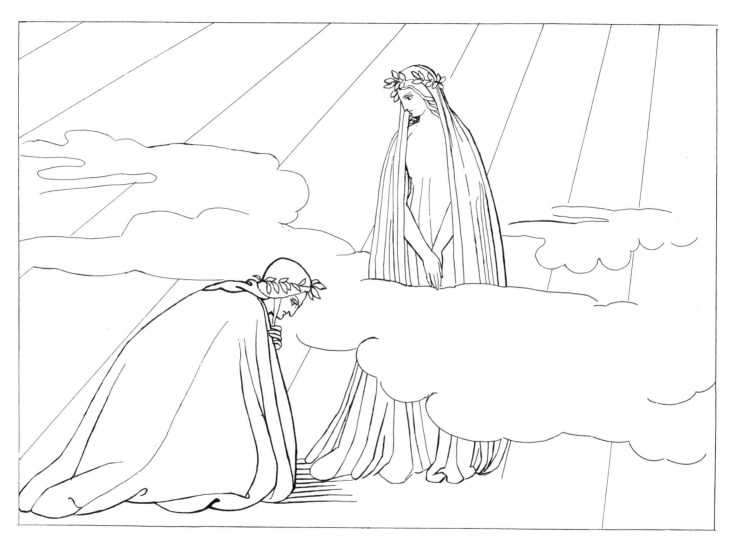

"Fix gratefully thy mind on God, who unto the first star has brought us"

Inhabitants of the Moon
Canto III, lines 10–18

Such as through polished and transparent glass,
 Or waters crystalline and undisturbed,
 But not so deep as that their bed be lost,
Come back again the outlines of our faces
 So feeble, that a pearl on forehead white
 Comes not less speedily unto our eyes;
Such saw I many faces prompt to speak,
 So that I ran in error opposite
 To that which kindled love 'twixt man and fountain.

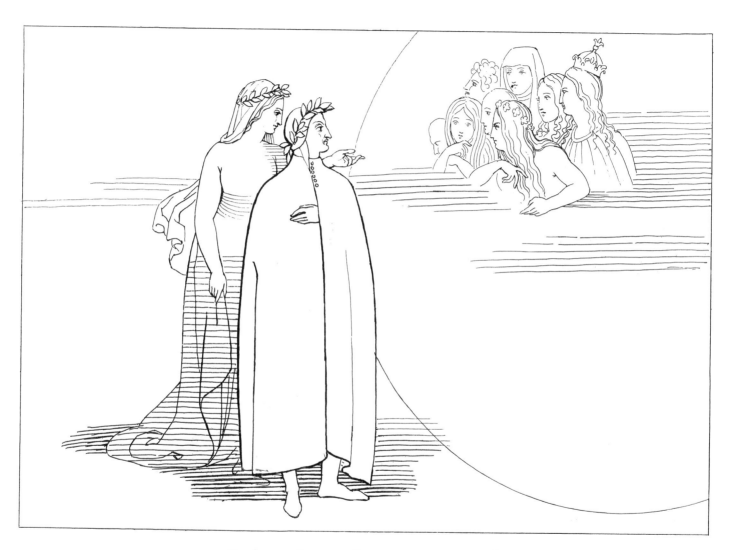

Such saw I many faces prompt to speak

Souls Returning to their Spheres
Canto IV, lines 19–24

Thou arguest, if good will be permanent,
The violence of others, for what reason
Doth it decrease the measure of my merit?
Again for doubting furnish thee occasion
Souls seeming to return unto the stars,
According to the sentiment of Plato.

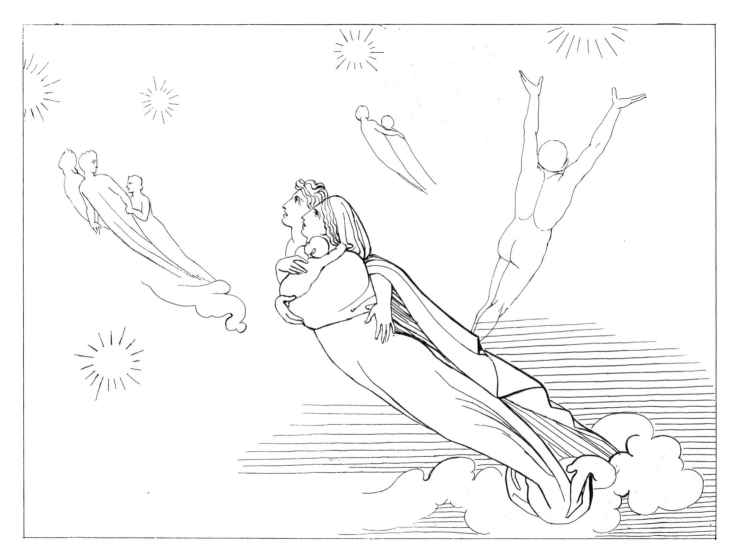

Souls seeming to return unto the stars

The Planet Mercury

Canto V, lines 100–105

As, in a fish-pond which is pure and tranquil,
The fishes draw to that which from without
Comes in such fashion that their food they deem it;
So I beheld more than a thousand splendours
Drawing towards us, and in each was heard:
"Lo, this is she who shall increase our love."

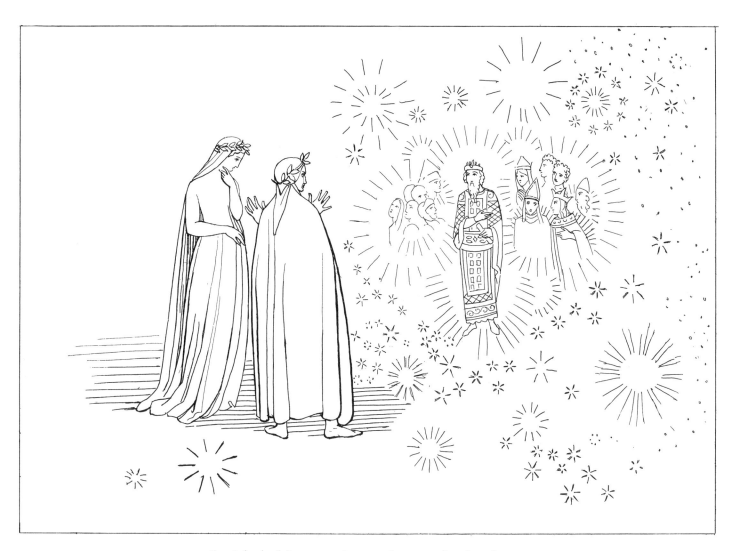

So I beheld more than a thousand splendours

The Active Good
Canto VI, lines 112–117

This little planet doth adorn itself
 With the good spirits that have active been,
 That fame and honour might come after them;
And whensoever the desires mount thither,
 Thus deviating, must perforce the rays
 Of the true love less vividly mount upward.

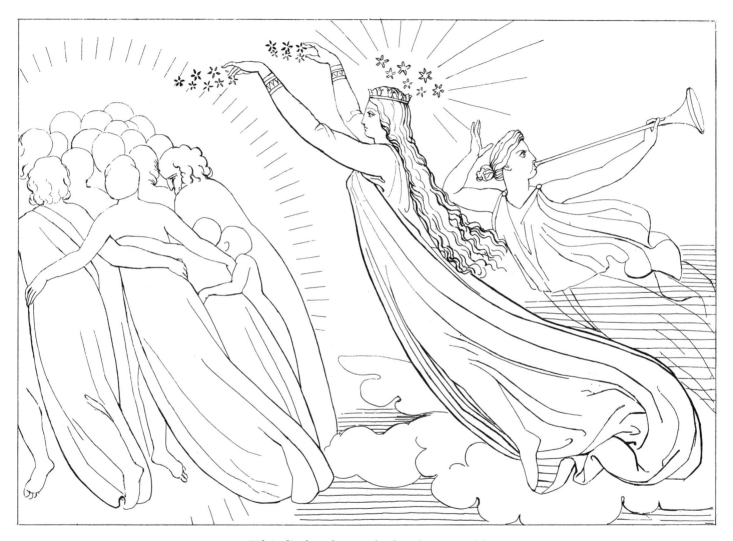

This little planet doth adorn itself
with the good spirits that have active been

Beatrice and Dante

Canto VII, lines 10–15

Doubting was I, and saying, "Tell her, tell her,"
Within me, "tell her," saying, "tell my Lady,"
Who slakes my thirst with her sweet effluences;
And yet that reverence which doth lord it over
The whole of me only by B and ICE,
Bowed me again like unto one who drowses.

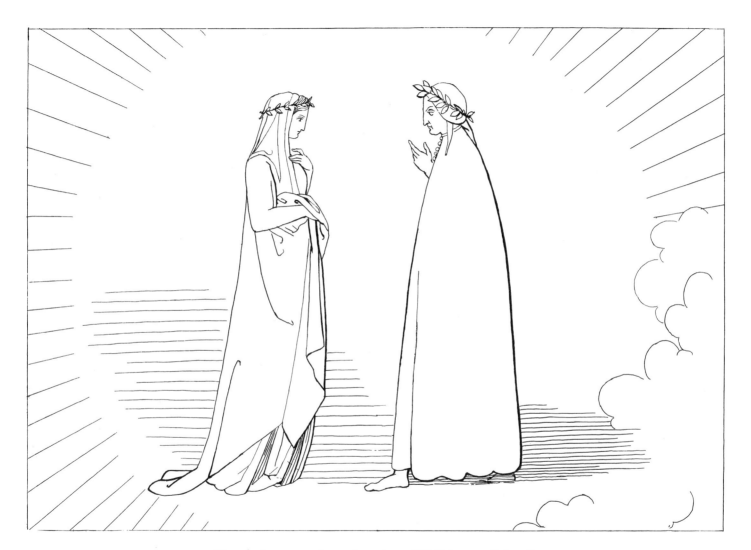

Doubting was I, and saying, "Tell her, tell her"

The Planet Venus

Canto VIII, lines 28–33

And behind those that most in front appeared
Sounded *"Osanna!"* so that never since
To hear again was I without desire.
Then unto us more nearly one approached,
And it alone began: "We all are ready
Unto thy pleasure, that thou joy in us."

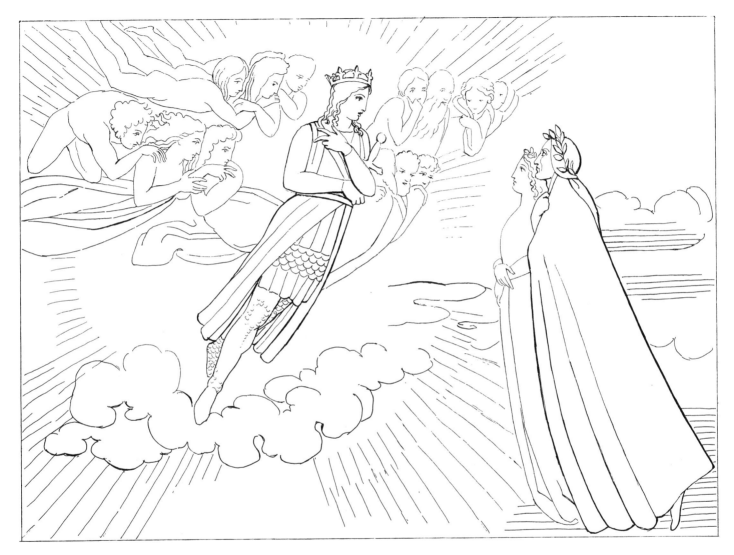

Then unto us more nearly one approached

The Return of Cunissa
Canto IX, lines 61–66

Above us there are mirrors, Thrones you call them,
 From which shines out on us God Judicant,
 So that this utterance seems good to us."
Here it was silent, and it had the semblance
 Of being turned elsewhither, by the wheel
 On which it entered as it was before.

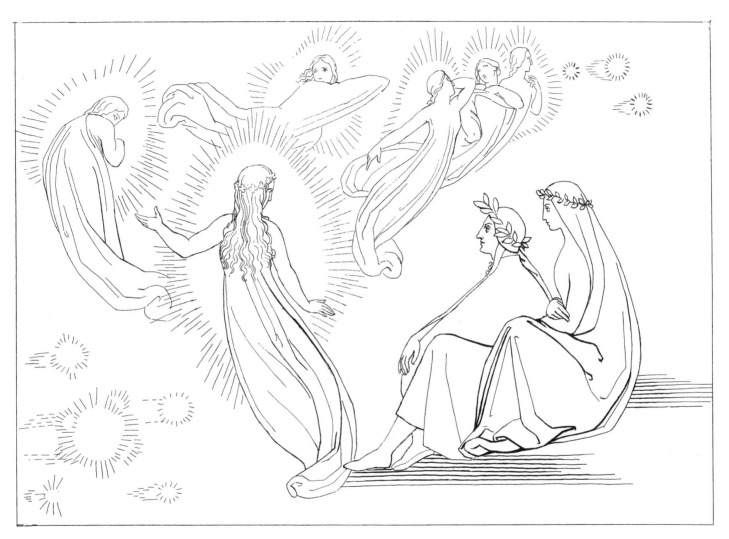

Here it was silent, and it had the semblance
of being turned elsewhither

The Sun
Canto X, lines 49–54

Such in this place was the fourth family
Of the high Father, who forever sates it,
Showing how he breathes forth and how begets.
And Beatrice began: "Give thanks, give thanks
Unto the Sun of Angels, who to this
Sensible one has raised thee by his grace!"

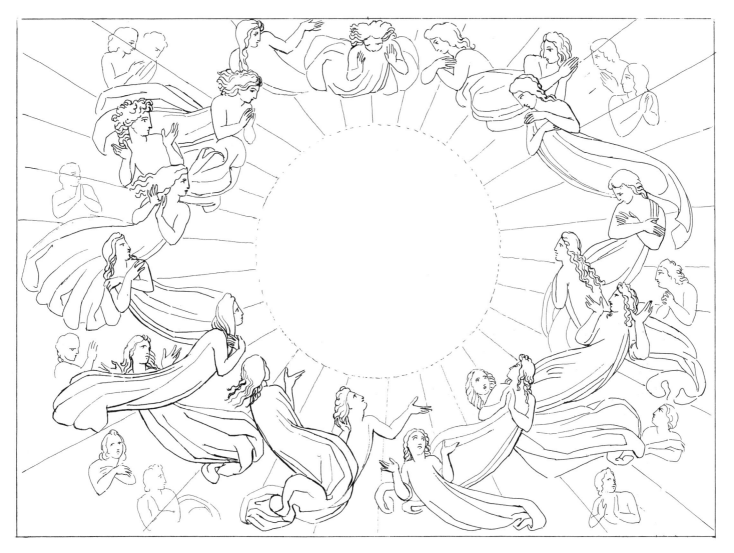

And Beatrice began: "Give thanks, give thanks unto the Sun of Angels"

The Church
Canto XI, lines 28–36

The Providence, which governeth the world
 With counsel, wherein all created vision
 Is vanquished ere it reach unto the bottom,
(So that towards her own Beloved might go
 The bride of Him who, uttering a loud cry,
 Espoused her with his consecrated blood,
Self-confident and unto Him more faithful,)
 Two Princes did ordain in her behoof,
 Which on this side and that might be her guide.

Two Princes did ordain in her behoof

The Region of the Sun

Canto XII, lines 10–21

And as are spanned athwart a tender cloud
 Two rainbows parallel and like in colour,
 When Juno to her handmaid gives command,
(The one without born of the one within,
 Like to the speaking of that vagrant one
 Whom love consumed as doth the sun the vapours,)
And make the people here, through covenant
 God set with Noah, presageful of the world
 That shall no more be covered with a flood,
In such wise of those sempiternal roses
 The garlands twain encompassed us about,
 And thus the outer to the inner answered.

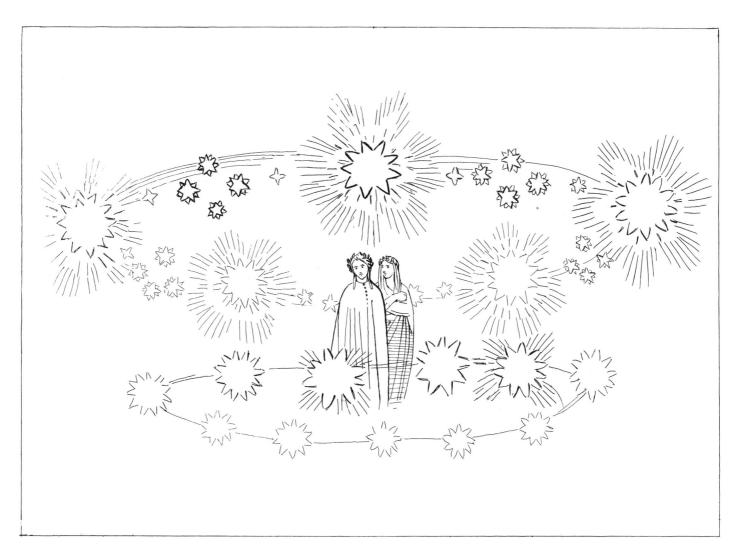

The garlands twain encompassed us about

The Adoration of the Trinity
Canto XIII, lines 22–27

Because it is as much beyond our wont,
As swifter than the motion of the Chiana
Moveth the heaven that all the rest outspeeds.
There sang they neither Bacchus, nor Apollo,
But in the divine nature Persons three,
And in one person the divine and human.

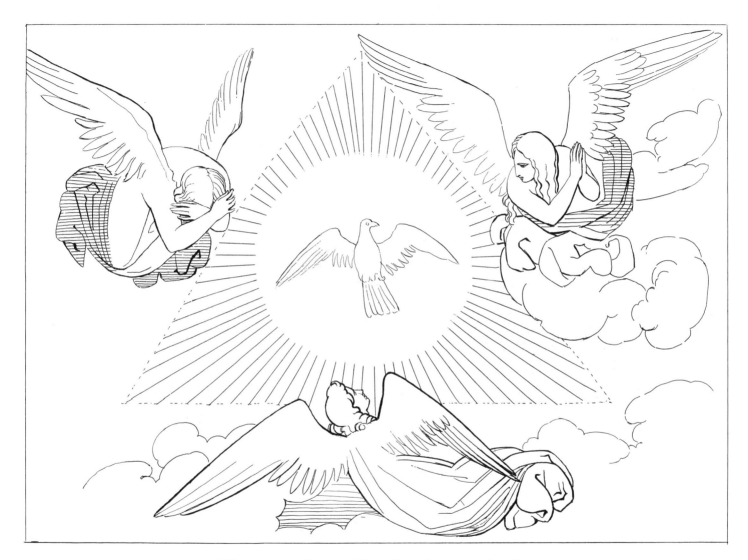

There sang they neither Bacchus, nor Apollo

The Glorious Cross
Canto XIV, lines 103–108

ere doth my memory overcome my genius;
For on that cross as levin gleamed forth Christ,
So that I cannot find ensample worthy;
But he who takes his cross and follows Christ
Again will pardon me what I omit,
Seeing in that aurora lighten Christ.

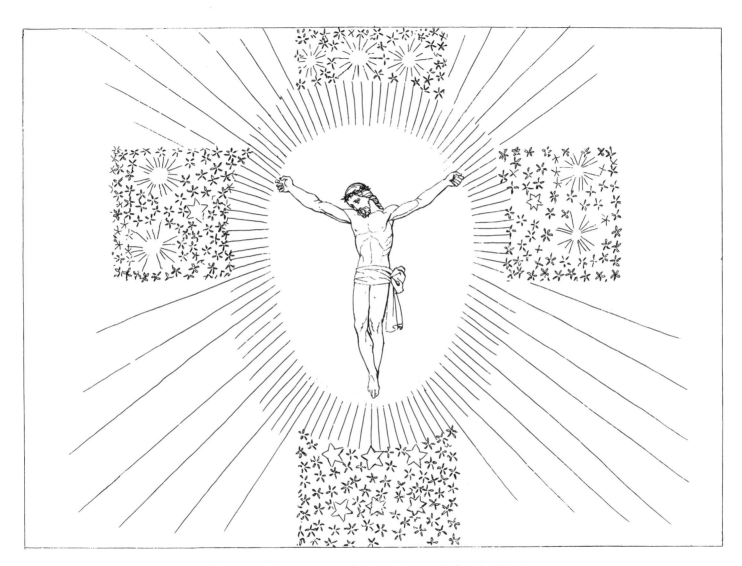

For on that cross as levin gleamed forth Christ

The Birth of Cacciaguida
Canto XV, lines 130–135

To such a quiet, such a beautiful
 Life of the citizen, to such a safe
Community, and to so sweet an inn,
Did Mary give me, with loud cries invoked,
And in your ancient Baptistery at once
Christian and Cacciaguida I became.

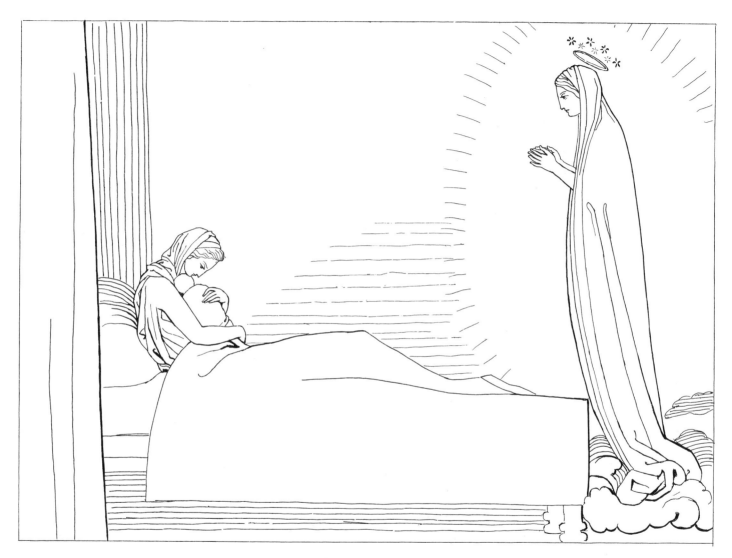

Did Mary give me

The Infant Saviour
Canto XVI, lines 34–39

From uttering of the *Ave,* till the birth
 In which my mother, who is now a saint,
 Of me was lightened who had been her burden,
Unto its Lion had this fire returned
 Five hundred fifty times and thirty more,
 To reinflame itself beneath his paw.

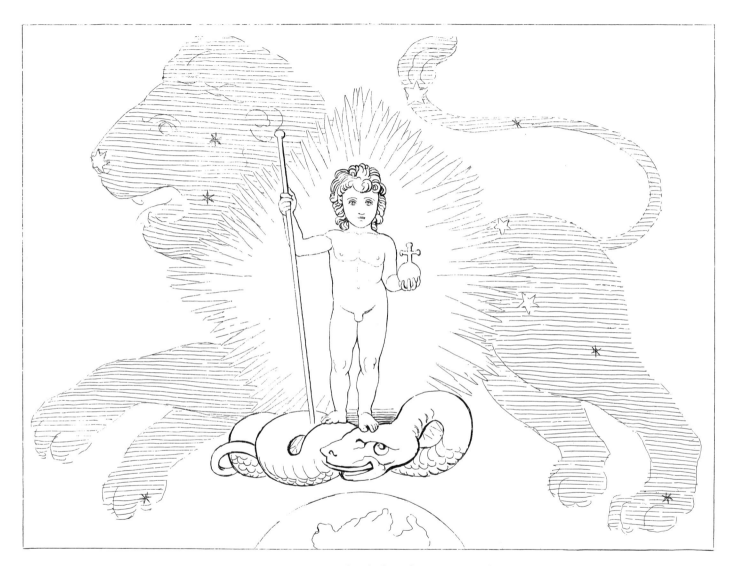

Unto its Lion had this fire returned

Dante Discoursing with Cacciaguida
Canto XVII, lines 106–111

Well see I, father mine, how spurreth on
 The time towards me such a blow to deal me
As heaviest is to him who most gives way.
Therefore with foresight it is well I arm me,
 That, if the dearest place be taken from me,
I may not lose the others by my songs.

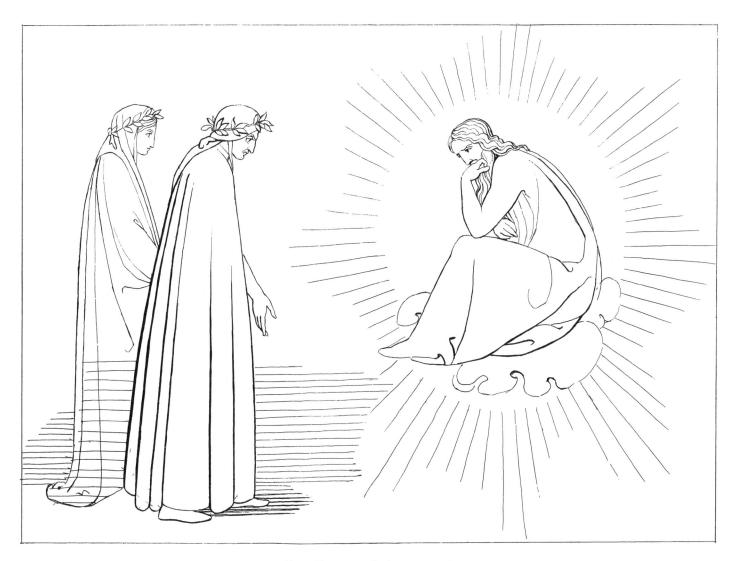

"Well see I, father mine"

The Planet Jupiter

Canto XVIII, lines 73–78

And even as birds uprisen from the shore,
 As in congratulation o'er their food,
 Make squadrons of themselves, now round, now long,
So from within those lights the holy creatures
 Sang flying to and fro, and in their figures
 Made of themselves now D, now I, now L.

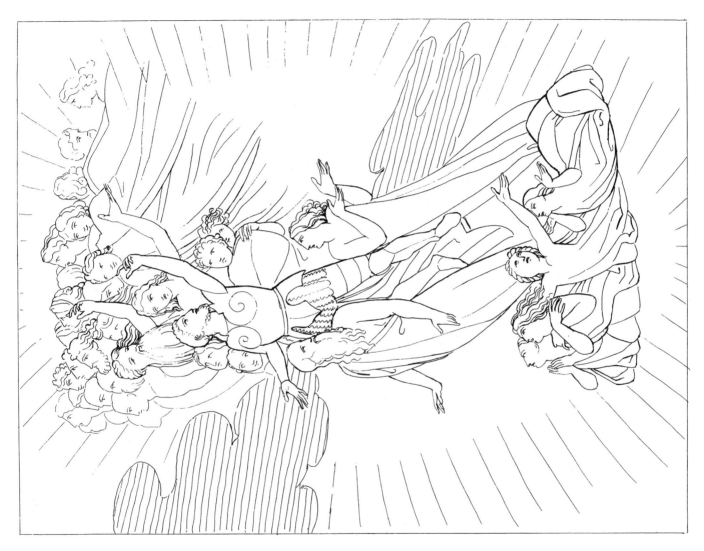

The holy creatures sang flying to and fro

The Celestial Eagle
Canto XIX, lines 1–6

Appeared before me with its wings outspread
 The beautiful image that in sweet fruition
 Made jubilant the interwoven souls;
Appeared a little ruby each, wherein
 Ray of the sun was burning so enkindled
 That each into mine eyes refracted it.

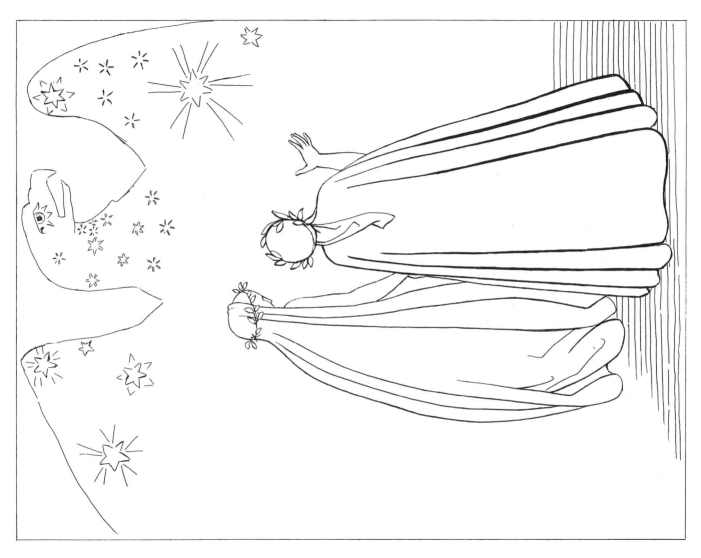

Appeared before me with its wings outspread

Heavenly Splendours
Canto XX, lines 64–69

ow knoweth he how heaven enamoured is
With a just king; and in the outward show
Of his effulgence he reveals it still.
Who would believe, down in the errant world,
That e'er the Trojan Ripheus in this round
Could be the fifth one of the holy lights?

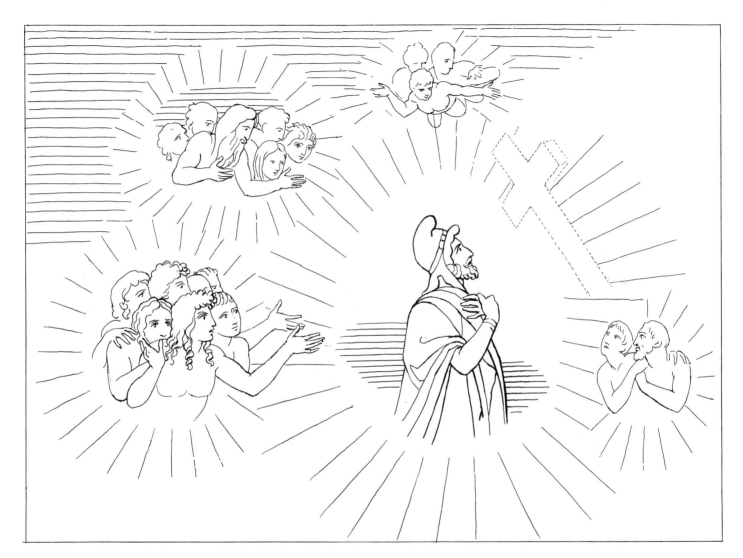

The Trojan Ripheus

The Celestial Steps
Canto XXI, lines 25–30

Within the crystal which, around the world
 Revolving, bears the name of its dear leader,
 Under whom every wickedness lay dead,
Coloured like gold, on which the sunshine gleams,
 A stairway I beheld to such a height
 Uplifted, that mine eye pursued it not.

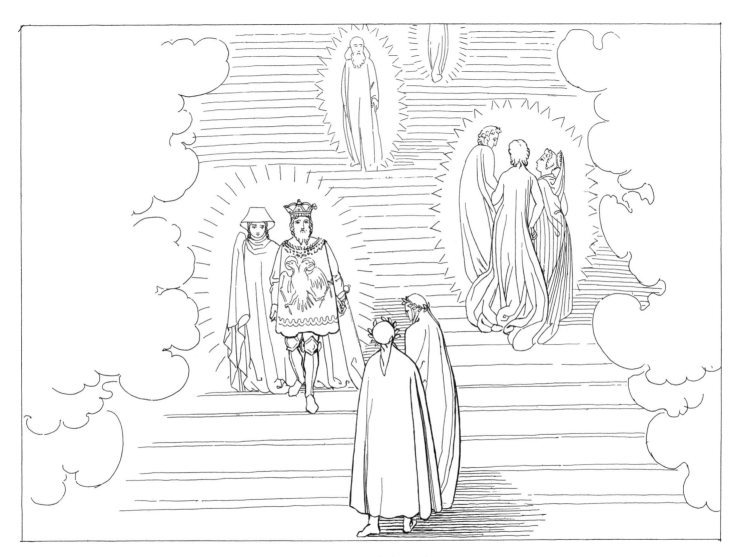

A stairway I beheld

The Terrors of Guilt
Canto XXII, lines 16–21

The sword above here smiteth not in haste
 Nor tardily, howe'er it seem to him
 Who fearing or desiring waits for it.
But turn thee round towards the others now,
 For very illustrious spirits shalt thou see,
 If thou thy sight directest as I say."

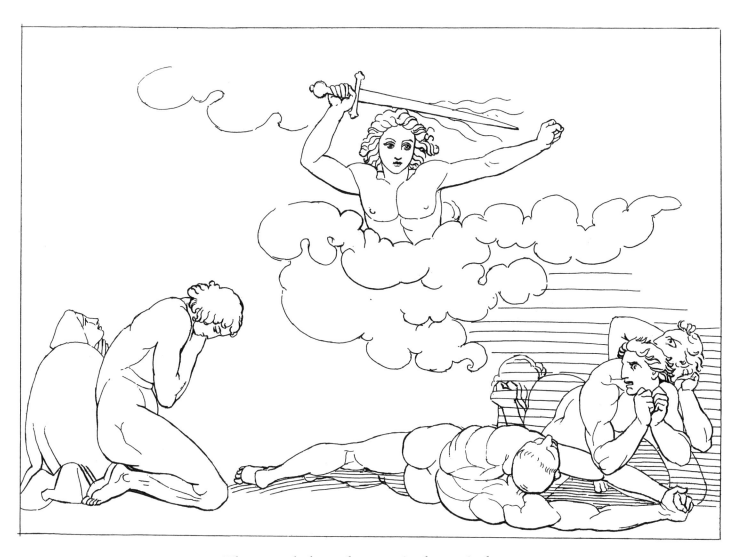

The sword above here smiteth not in haste

The Triumph of Christ

Canto XXIII, lines 19–21

And Beatrice exclaimed: "Behold the hosts
Of Christ's triumphal march, and all the fruit
Harvested by the rolling of these spheres!"

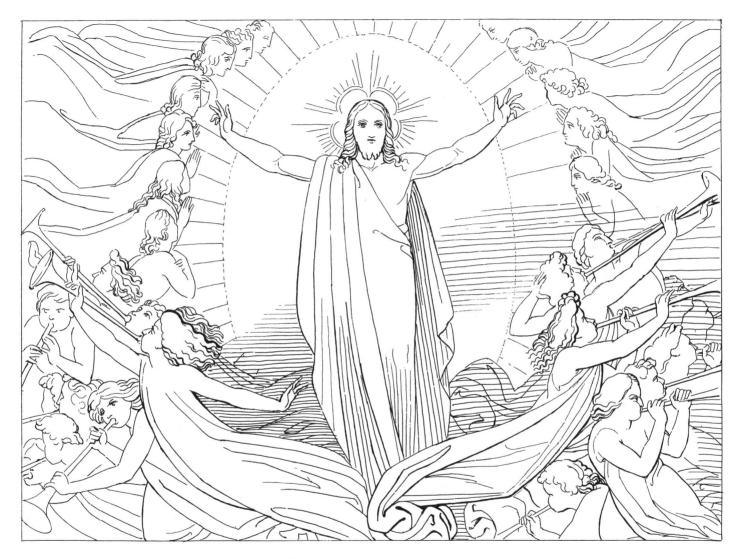

Christ's triumphal march

St. Peter

Canto XXIV, lines 10–12

Thus Beatrice; and those souls beatified
Transformed themselves to spheres on steadfast poles,
Flaming intensely in the guise of comets.

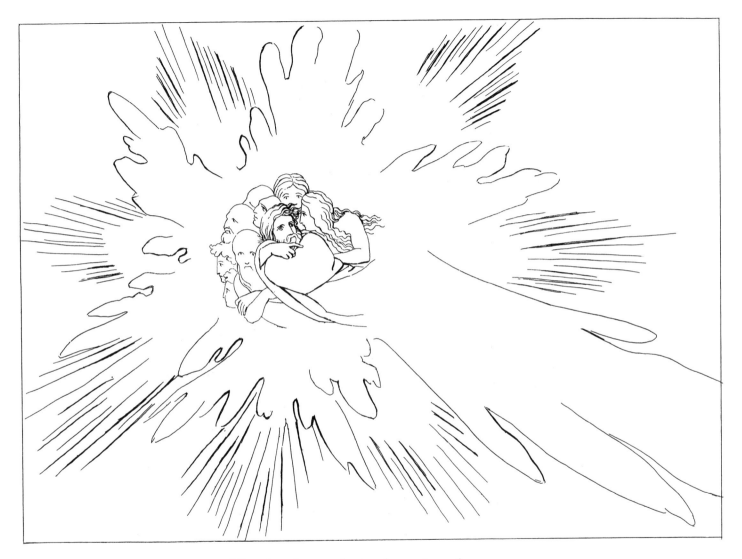

Flaming intensely in the guise of comets

The Church Militant

Canto XXV, lines 49–54

And the Compassionate, who piloted
 The plumage of my wings in such high flight,
 Did in reply anticipate me thus:
"No child whatever the Church Militant
 Of greater hope possesses, as is written
 In that Sun which irradiates all our band . . ."

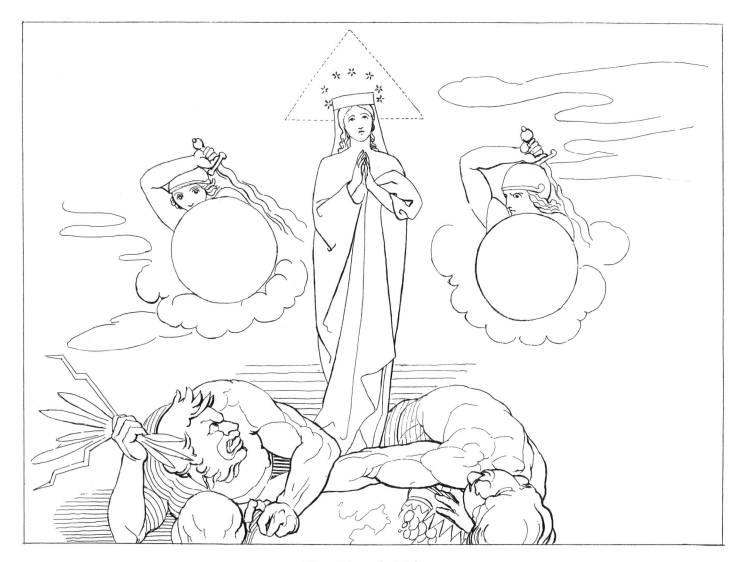

The Church Militant

Conference with St. John

Canto XXVI, lines 7–9

Begin then, and declare to what thy soul
Is aimed, and count it for a certainty,
Sight is in thee bewildered and not dead"

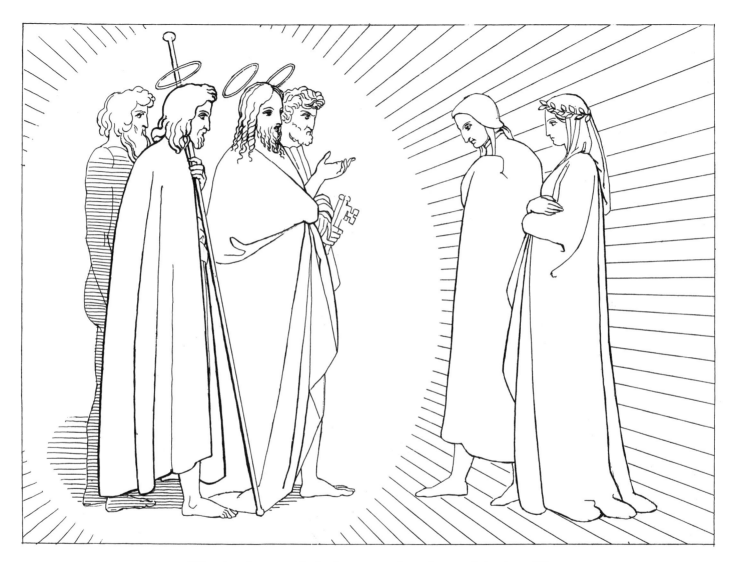

"Begin then, and declare to what thy soul is aimed"

The Ninth Sphere
Canto XXVII, lines 1–9

Glory be to the Father, to the Son,
 And Holy Ghost!" all Paradise began,
 So that the melody inebriate made me.
What I beheld seemed unto me a smile
 Of the universe; for my inebriation
 Found entrance through the hearing and the sight.
O joy! O gladness inexpressible!
 O perfect life of love and peacefulness!
 O riches without hankering secure!

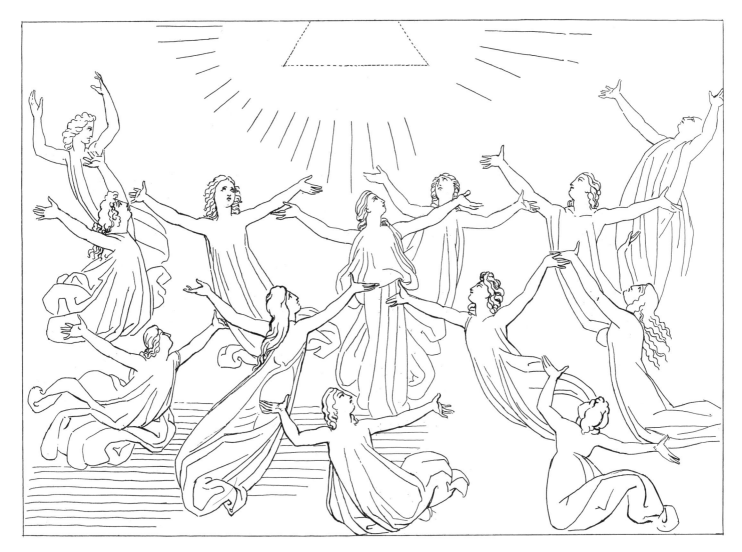

"Glory be to the Father, to the Son, and Holy Ghost!"

Heaven ❧ 209

The Empyreum
Canto XXVIII, lines 22–27

Perhaps at such a distance as appears
 A halo cincturing the light that paints it,
 When densest is the vapour that sustains it,
Thus distant round the point a circle of fire
 So swiftly whirled, that it would have surpassed
 Whatever motion soonest girds the world

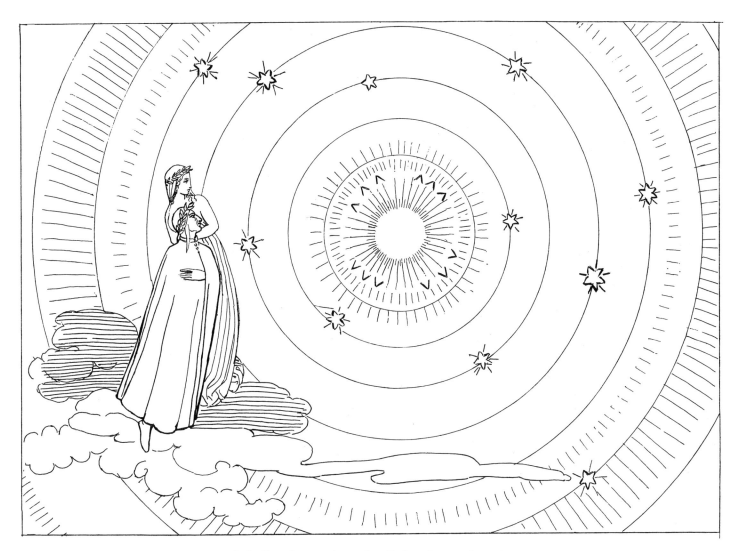

A halo cincturing the light that paints it

The Hierarchies

Canto XXIX, lines 37–42

Jerome has written unto you of angels
Created a long lapse of centuries
Or ever yet the other world was made;
But written is this truth in many places
By writers of the Holy Ghost, and thou
Shalt see it, if thou lookest well thereat.

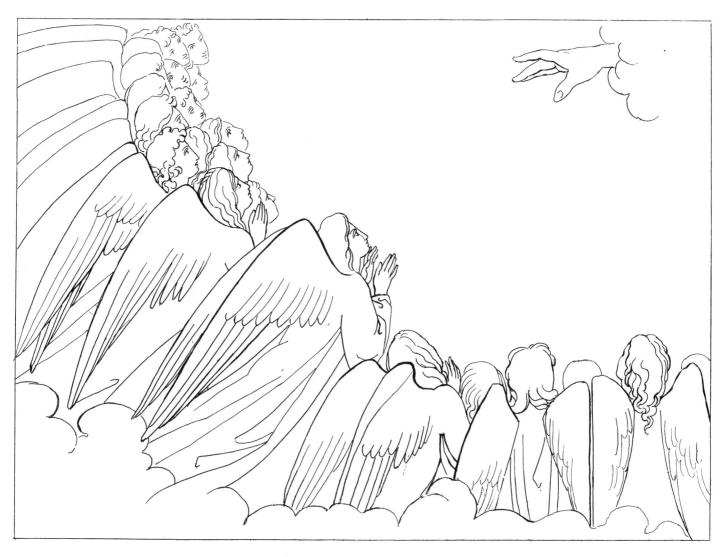

Jerome has written unto you of angels

Celestial Meteors
Canto XXX, lines 91–96

Then as a folk who have been under masks
 Seem other than before, if they divest
 The semblance not their own they disappeared in,
Thus into greater pomp were changed for me
 The flowerets and the sparks, so that I saw
 Both of the Courts of Heaven made manifest.

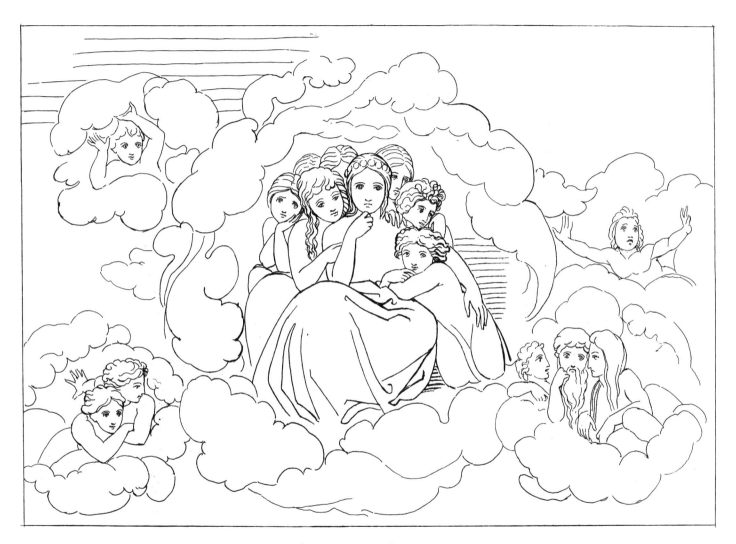

The Courts of Heaven

The Virgin Mary

Canto XXXI, lines 112–117

Thou son of grace, this jocund life," began he,
"Will not be known to thee by keeping ever
Thine eyes below here on the lowest place;
But mark the circles to the most remote,
Until thou shalt behold enthroned the Queen
To whom this realm is subject and devoted."

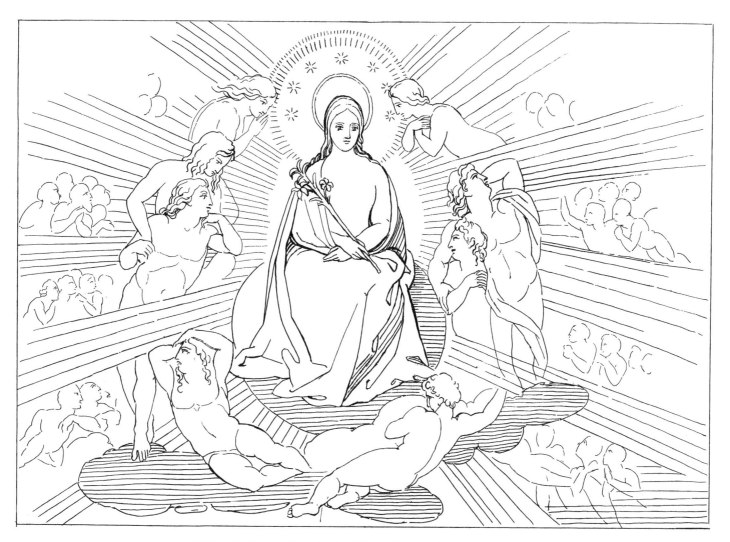

"Until thou shalt behold enthroned the Queen"

Order of the Patriarchs
Canto XXXII, lines 1–6

Absorbed in his delight, that contemplator
Assumed the willing office of a teacher,
And gave beginning to these holy words:
"The wound that Mary closed up and anointed,
She at her feet who is so beautiful,
She is the one who opened it and pierced it."

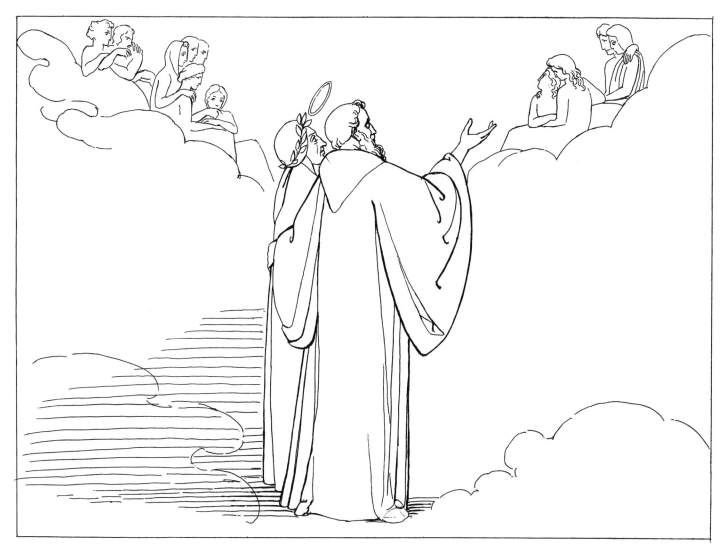

Absorbed in his delight, that contemplator
assumed the willing office of a teacher

The Beatific Vision
Canto XXXIII, lines 115–120

Within the deep and luminous subsistence
 Of the High Light appeared to me three circles,
 Of threefold colour and of one dimension,
And by the second seemed the first reflected
 As Iris is by Iris, and the third
 Seemed fire that equally from both is breathed.

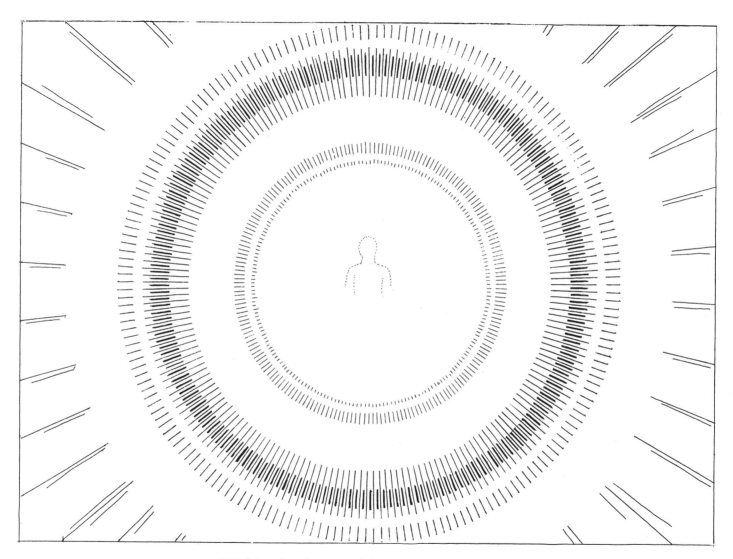

Within the deep and luminous subsistence
of the High Light appeared to me three circles